ideals EASTER

Spring came walking through the grass;
I heard her happy footsteps pass;
I went outside and took her hand
and followed her across the land.
And everywhere we took our way,
the flowers called a holiday.

—ANNETTE WYNNE

NASHVILLE, TENNESSEE

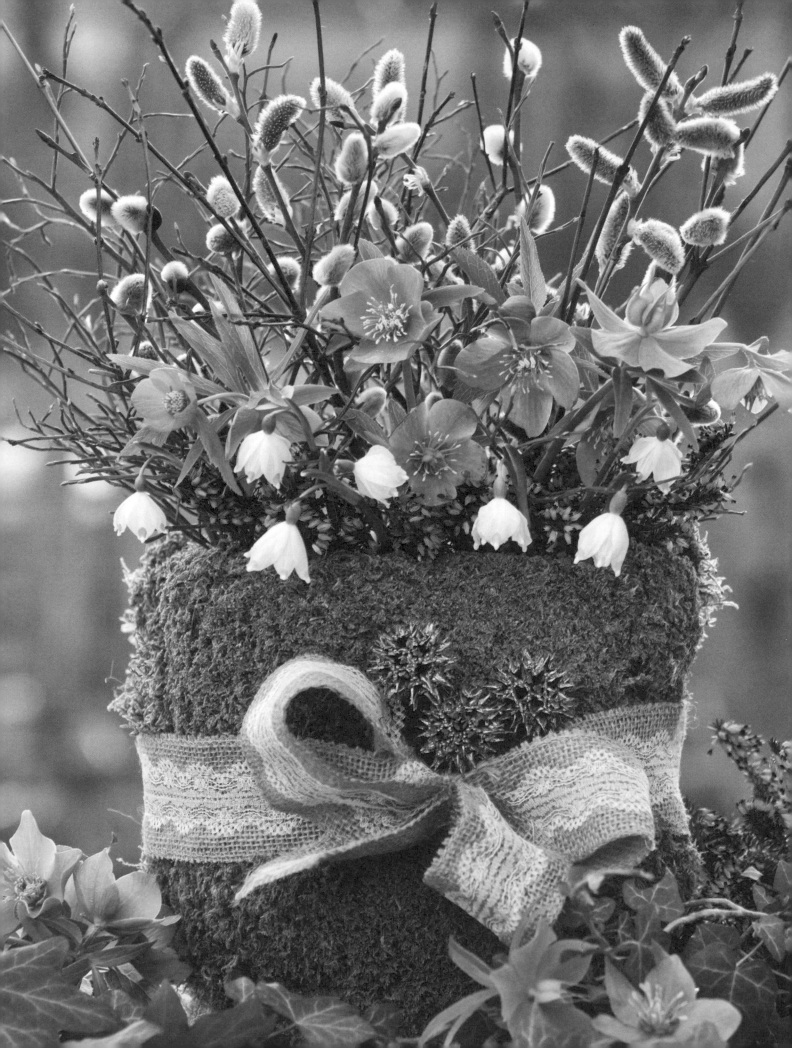

The First Spring Day

Christina Rossetti

I wonder if the sap is stirring yet,
if wintry birds are dreaming of a mate,
if frozen snowdrops feel as yet the sun
and crocus fires are kindling one by one:
sing, robin, sing!
I still am sore in doubt
 concerning spring.

I wonder if the springtide of this year
will bring another spring both
 lost and dear;
if heart and spirit will find out their spring,
or if the world alone will bud and sing:
sing, hope, to me!

Sweet notes, my hope,
 soft notes for memory.

The sap will surely quicken
 soon or late,
the tardiest bird will twitter to
 a mate;
so spring must dawn again
 with warmth and bloom
or in this world, or in the world
 to come:
sing, voice of spring!
Till I, too, blossom and
 rejoice and sing.

Pussy Willows

Garnett Ann Schultz

I don't believe it's winter;
I saw a sign of spring;
the snowflakes quickly melted;
I heard a robin sing.
The calendar is fooling,
for spring is in the air;
the pussy willows told me;
I saw them budding there.

I don't believe it's snow time;
the sun is stealing through;
and, see, the clouds have vanished;
the sky is bright and blue.
Those precious pussy willows
have told me winter's through;
for they believe it's springtime—
and I believe it too.

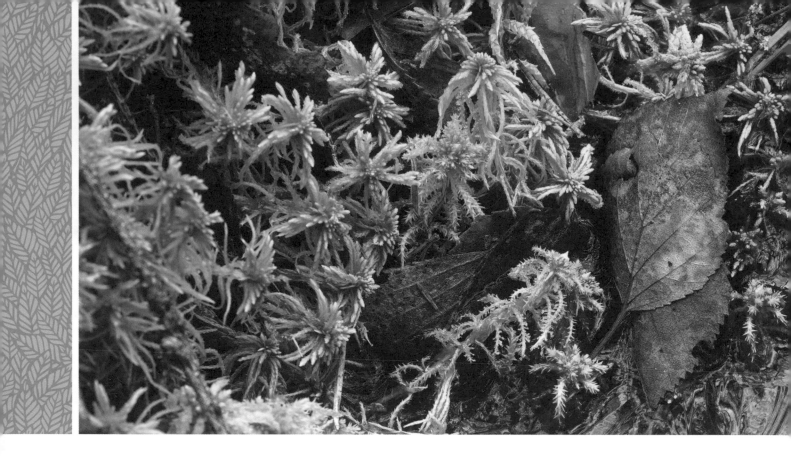

Spring

from WALDEN

Henry David Thoreau

The phenomena of the year take place every day in a pond on a small scale. Every morning, generally speaking, the shallow water is being warmed more rapidly than the deep, though it may not be made so warm after all, and every evening it is being cooled more rapidly until the morning. The day is an epitome of the year. The night is the winter, the morning and evening are the spring and fall, and the noon is the summer. The cracking and booming of the ice indicate a change of temperature. One pleasant morning after a cold night, February 24th, 1850, having gone to Flint's Pond to spend the day, I noticed with surprise, that when I struck the ice with the head of my axe, it resounded like a gong for many rods around, or as if I had struck on a tight drumhead. The pond began to boom about an hour after sunrise, when it felt the influence of the sun's rays slanted upon it from over the hills; it stretched itself and yawned like a waking man with a gradually increasing tumult, which was kept up three or four hours. It took a short siesta at noon, and boomed once more toward night, as the sun was withdrawing his influence. In the right stage of the weather a pond fires its evening gun with great regularity. But in the middle of the day, being full of cracks, and the air also being less elastic, it had completely lost its resonance, and probably fishes and muskrats could not then have been stunned by a blow on it. The fishermen say that the "thundering of the pond" scares the fishes and prevents their biting. The pond does not thunder every evening, and I cannot tell surely when to expect its thundering; but though I may perceive no difference in the weather, it does. Who

would have suspected so large and cold and thick-skinned a thing to be so sensitive? Yet it has its law to which it thunders obedience when it should as surely as the buds expand in the spring. The earth is all alive and covered with papillae. The largest pond is as sensitive to atmospheric changes as the globule of mercury in its tube.

One attraction in coming to the woods to live was that I should have leisure and opportunity to see the spring come in. The ice in the pond at length begins to be honeycombed, and I can set my heel in it as I walk. Fogs and rains and warmer suns are gradually melting the snow; the days have grown sensibly longer; and I see how I shall get through the winter without adding to my wood-pile, for large fires are no longer necessary. I am on the alert for the first signs of spring, to hear the chance note of some arriving bird, or the striped squirrel's chirp, for his stores must be now nearly exhausted, or see the woodchuck venture out of his winter quarters. On the 13th of March, after I had heard the bluebird, song-sparrow, and red-wing, the ice was still nearly a foot thick. As the weather grew warmer, it was not sensibly worn away by the water, nor broken up and floated off as in rivers, but, though it was completely melted for half a rod in width about the shore, the middle was merely honeycombed and saturated with water, so that you could put your foot through it when six inches thick; but by the next day evening, per-haps, after a warm rain followed by fog, it would have wholly disappeared, all gone off with the fog, spirited away. One year I went across the middle only five days before it disappeared entirely. . . .

Every incident connected with the breaking up of the rivers and ponds and the settling of the weather is particularly interesting to us who live in a climate of so great extremes. When the warmer days come, they who dwell near the river hear the ice crack at night with a startling whoop as loud as artillery, as if its icy fetters were rent from end to end, and within a few days see it rapidly going out.

Spring's Promise Fulfilled

Andrew L. Luna

There is nothing so intent upon its purpose as the daffodil announcing the arrival of spring. Green shoots rise up from its bulb beneath the ground and force their way up through the fallow, winter-swept soil. Before you know it, bright yellow flowers emerge from the tops of the shoots as trumpet-like corona reach up to the sun to proudly proclaim that winter has finally accomplished its purpose and has given way to the joys and colors of spring.

Everywhere you look, there are daffodils standing in contrast to grass, which was once dull brown but now shows a hint of green. Almost every house, garden, or roadside displays the joyous yellow flowers and causes onlookers to pause for a moment to notice that the weather is, indeed, getting just a little warmer and the sun hangs in the sky just a little longer. During some years, a thin blanket of snow will cover freshly emerging daffodils as winter tries to hold on a bit longer. Soon, however, the snow will melt and the daffodil will emerge as victor.

One day in the early spring, I was walking deep in the woods where no sign of past or present civilization could be found. Coming up on a small rise in the terrain, I noticed something distinct in the dappled sunlight filtering though trees just starting to bear their leaves. There, through the dead vegetation and vine overgrowth, I saw the welcoming sight of evenly spread clumps of bright, yellow daffodils.

While the blooms seemed out of place, I knew their presence was not random. At some point, many years ago, those daffodils were planted by someone in a flower garden or along a pathway leading up to a home that has long since gone. The vacant site was probably an old homestead built a hundred or more years ago, and the planter was perhaps a woman who wanted to see the arrival of spring as she looked out her kitchen window.

Even though the people and homestead have vanished like a gentle mist rising above the trees during an early-morning sunrise, the daffodils left in the ground so many years ago serve as enduring voices of tenacity and conviction, as well as welcoming rays of sunshine and the hope for better days ahead.

While the robin and the crocus also announce the arrival of spring in their own unique ways, it is the yellow trumpeted flowers of antiquity that proclaim a faith that spring will come again with its newness, rebirth, and change. The daffodil is spring's promise fulfilled.

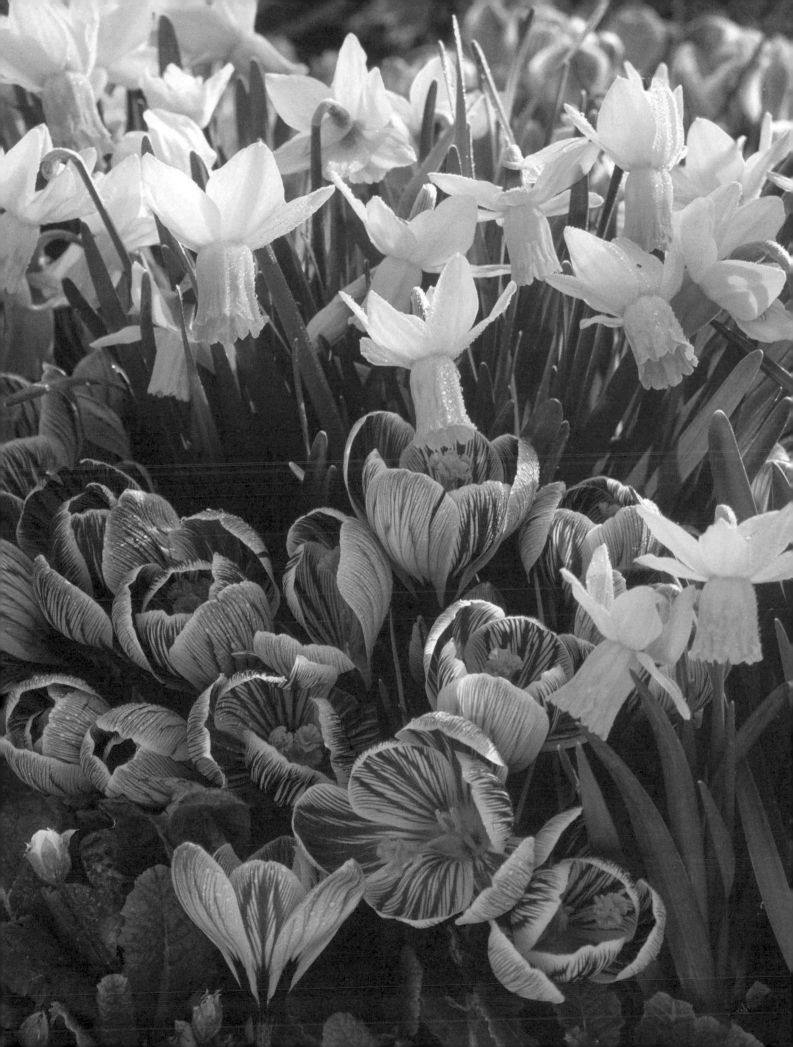

Nature's Easter Music

Lucy Larcom

The flowers from the earth have arisen
and are singing their Easter song;
through the valleys and over
 the hillsides
they come, an unnumbered throng.

Oh, listen! The wildflowers
 are singing
their beautiful songs without words!
They are pouring the soul of
 their music
through the voices of happy birds.

Every flower to a bird has confided
the joy of its blossoming birth—

the wonder of its resurrection
from its grave in the frozen earth.

The buttercup's thanks for
 the sunshine,
the goldfinch's twitter reveals;
and the violet trills, through
 the bluebird,
of the heaven that within
 her she feels.

The song-sparrow's exquisite warble
is born in the heart of the rose—
of the wild-rose, shut in its calyx,
afraid of belated snows.

Easter in the Woods

Frances Frost

This dawn when the
 mountain cherry lifts
its frail, white bloom among dark pines
and chipmunks flash small, happy paws
along old tumbled boundary lines,
this golden morning when the vixen
nuzzles her five young foxes forth
to roll in ferns in the Easter sun,
again the woods know soft green birth.

Snuffed by a puffball infant rabbit
are yellow violets by the spring;
among half-opened apple buds
a wood thrush tilts its head to sing.
Risen is He! And they are His
who scamper under warm blue skies,
who nibble little fists of grass,
and gaze on the earth with glad eyes.

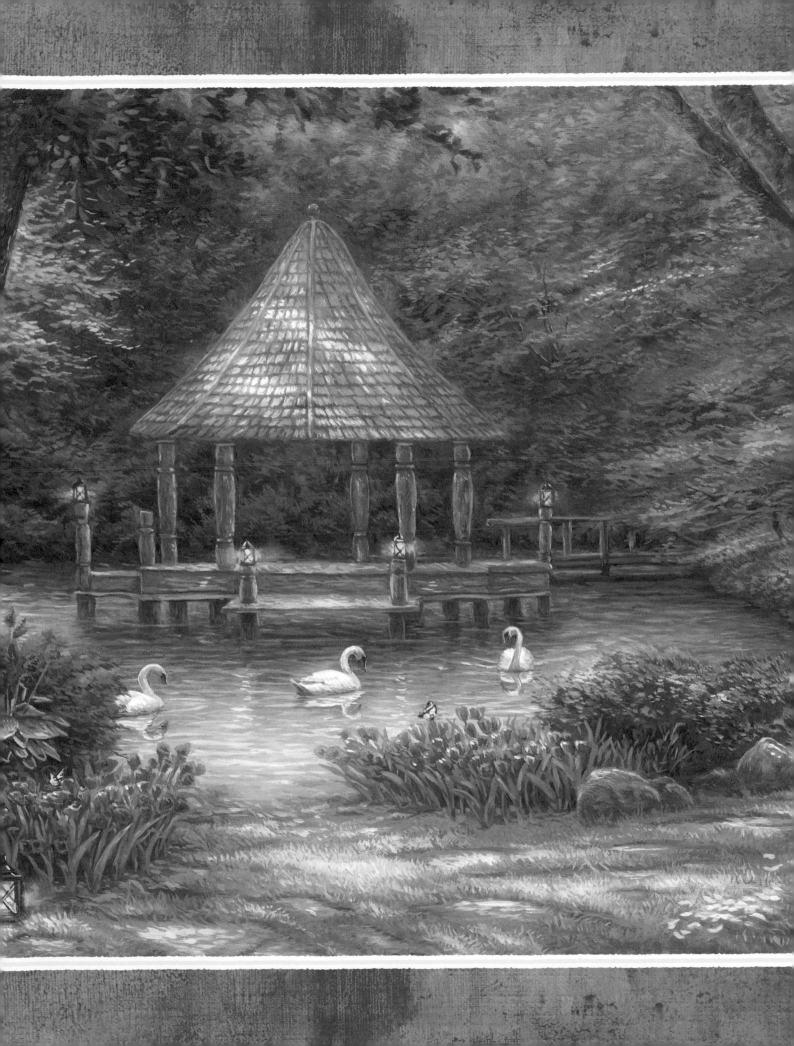

Go Fly a Kite

Faith Andrews Bedford

A strong March breeze blows our flag almost straight out. Against a backdrop of clear blue sky, the Stars and Stripes flutters and flaps with each gust. My husband comes inside and leans against the door.

"It's a beautiful day to fly a kite," he says, hanging his coat on a peg. "Too bad we don't have one anymore."

"Want to make one?" I ask.

Bob stops short with surprise, then grins. "Sure," he says. "I'll see if we've got any dowels in the workshop."

As Bob heads downstairs I remember the many kites we've flown over the years. There were colorful box kites and Mylar kites that glistened iridescently in the sunlight. On Father's Day one year the children gave Bob a stunt kite that had several strings. By pulling on first one, then another, he could make it dive and swirl, do loop-the-loops, and dip and soar.

Of all the kites we've had, the ones I loved the most were the ones we made ourselves. They were simple affairs, really. Just two crossed sticks, some string and some paper. The children decorated them with wonderful designs, painting some to look like dragons with flaming tails, some to look like birds. Others were decorated with flowers or animals, funny faces or abstract designs worthy of Picasso.

Sometimes our homemade kites were a bit wild in flight, so we had to race back inside, find the ragbag, and tear up an old sheet to make tails. At other times, Bob would fasten the kites to his fishing rod with the line shrieking through the reel as it ran out and the children vying for turns to reel the kite in. Bob's fishing-rod arrangement made for some interesting comments from passersby on the beach. Following our upward gaze, they would laugh and often say something like, "Looks like you caught a big one there." Such comments inspired the children to make a number of fish kites.

The kids loved sending notes up the kite strings. They would write a wish on a piece of paper, cut a slit on one side, and slip it on the kite string. The wind, vibrating across the string, would set the note dancing. In slow circles the note crept higher and higher up the string toward the kite until it was out of sight. When we pulled in the kite, the notes were always gone. Our daughter Eleanor decided they must have been snatched by angels.

At the top of a mountain not far from our home sits a cluster of cottages. Each year, residents of the mountain hold "Kite Day." Some years back, one of my husband's students who lived on the mountain invited us to bring the children and join the festivities. The week before was spent in feverish activity as Bob and the children spent every evening down in the shop putting the finishing touches on their kites.

The long-awaited day dawned bright and sunny with a nice strong breeze blowing in from the southwest. We packed a picnic, herded everyone into the station wagon, and headed for the mountain, each child carefully guarding his or her creation on the trip.

Bob helped the kids launch their kites and then we lay on a blanket watching them as they flew their celestial works of art. Each child had a different approach. Drew urged his purple and green dragon higher and higher by running up and

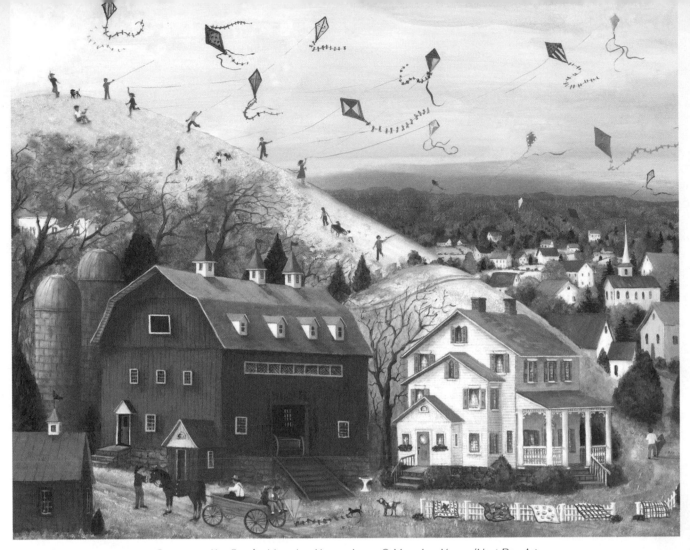

COMMUNITY KITE FEST *by Mary Ann Vessey. Image © Mary Ann Vessey/Next Day Art*

down the slope to help it gain altitude. Sarah, our youngest, tugged often at her string, looking back at us for instructions. Every now and then we saw her move across the grass to help a younger child untangle her string or add more bits of ribbon to a tail. Eleanor stood in one place carefully playing out the line as her kite soared ever upward. She tipped her head back and studied the pattern that her bird-kite made against the sky and stayed on the hill long after most of the other children had tired of the sport. As families began to gather for the evening picnic, Eleanor let her kite go. By the time she reached our blanket, it was only a tiny speck in the pale blue sky.

The children had made the kites; they were theirs to do with as they wished. Nonetheless, we were surprised. "Why did you let it go?" I asked her.

She simply replied, "Because it wanted to be free."

A few years ago, when my friend Susan learned that Eleanor was going to a recently war-torn country in Africa to work as the director of a project that would help rebuild schools and roads, bridges and hospitals, she asked, "How can you let her go to such a dangerous place?"

"*Let* was not the right word," I replied. I had not told her what to do since she'd finished school. What I did not tell Susan was that, like notes on a kite string, I had said many prayers for Eleanor's safety, praying that a guardian angel would watch over her. As parents, we can only hope that when we finally let go of the string, our children will be happy and free, strong enough to weather any storm.

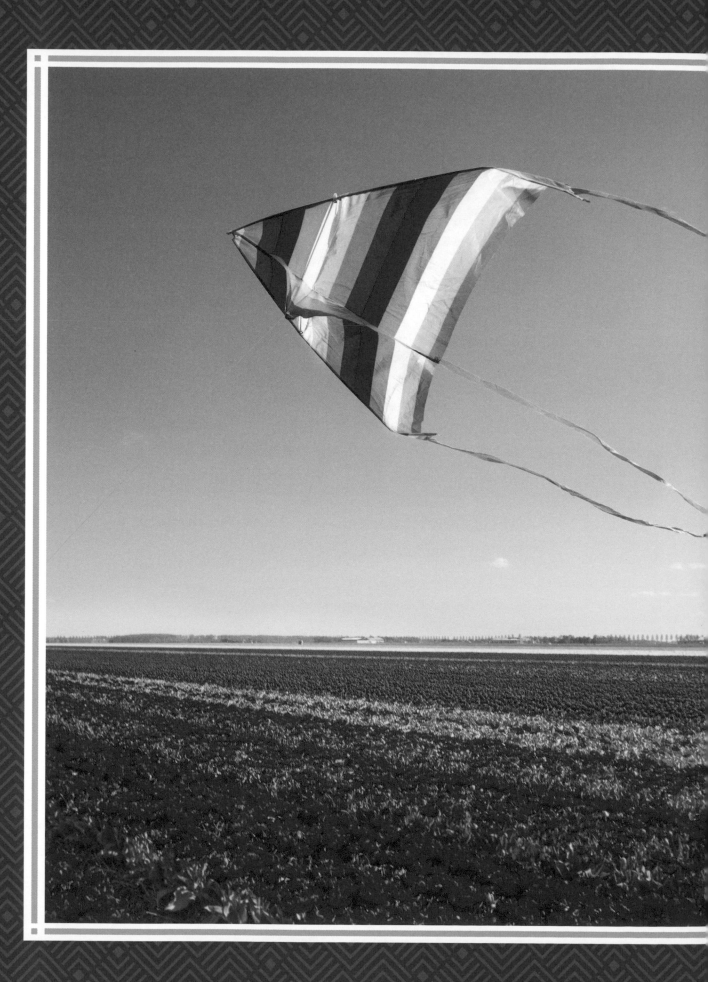

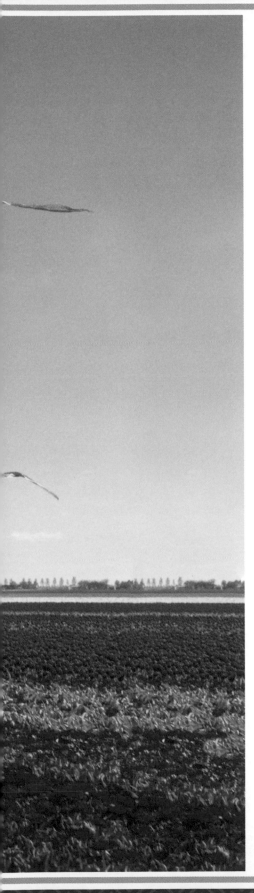

How bright on the blue
is a kite when it's new?
—HARRY BEHN

The Wind

Robert Louis Stevenson

I saw you toss the kites on high
and blow the birds about the sky;
and all around I heard you pass,
like ladies' skirts across the grass—
O wind, a-blowing all day long,
O wind, that sings so loud a song!

I saw the different things you did,
but always you yourself you hid.
I felt you push, I heard you call,
I could not see yourself at all—
O wind, a-blowing all day long,
O wind, that sings so loud a song!

O you that are so strong and cold,
O blower, are you young or old?
Are you a beast of field and tree,
or just a stronger child than me?
O wind, a-blowing all day long,
O wind, that sings so loud a song!

Hepaticas

Hal Borland

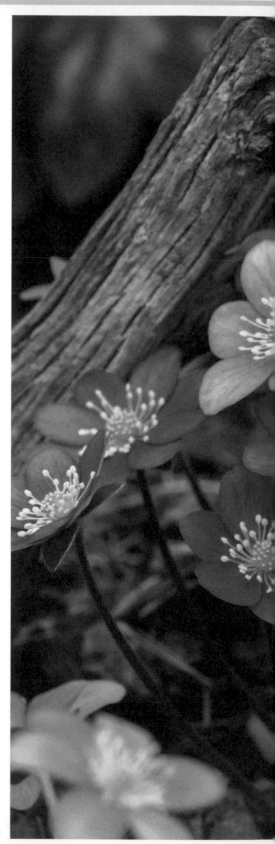

Some call them hepaticas, some call them liverworts, but all know them as the first flowers in the woodland. The blossoms, no more than an inch across, vary from lavender-tinged white to pale purple, and they burst bud on hairy stems that rise from winter-worn leaves before the first new leaves appear. They grow on rocky hillsides where rich pockets of leaf mold catch the ooze and trickle of late March and early April. On a sunny day they are like flecks of cloudless sky on the littered floor of the leafless woodland.

We cherish them not because of their special beauty but because they bloom so early. They are, in a sense, the triumph of spring, the first triumph of the vital root and the urgent bud. Snowbanks may still be melting on the slope above them. Nights may still be fanged with frost. But the hepaticas dare to send up a stem and fatten a bud, and the petals open with what we can only call confidence that the earliest bees will come to their pollen. They bloom when April is still deliberating the reality of spring.

In another few weeks they will be lost in the spreading shadow of new leaves and even the bees will ignore them. Anemones will be sparkling the woodland, trout lilies will be in bloom, and violets. Bloodroot will spread its waxen white petal. Columbine will demand the eye with its flash of gold and crimson. The pollen-rich rush will have begun. But first come the hepaticas, early April's covenant with spring.

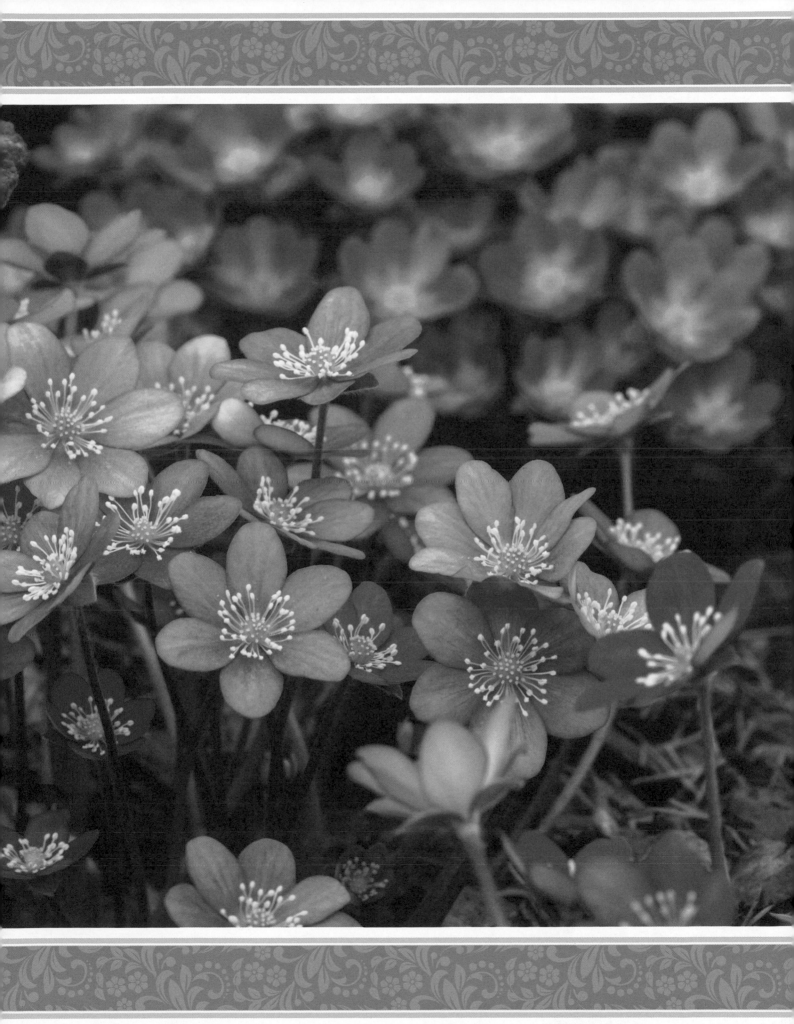

Bits & Pieces

There is poetry among the wildflowers.
—*Rachel Irene Stevenson*

Wildflowers—I envy them.
They're brave. Seeds cast by
the wind to land where they may,
they stay and hold against most hot,
most cold. They persevere, roots
shallow yet fierce and free. They epitomize
to me all that I sometimes yearn to be.
—*Julie Andrews*

Love is like wildflowers; it's often
found in the most unlikely places.
—*Ralph Waldo Emerson*

Almost every person, from
childhood on, has been touched by
the untamed beauty of wildflowers.
—*Lady Bird Johnson*

*H*ow lavishly are the flowers scattered over the face of the earth! One of the most perfect and delightful works of the Creation, there is yet no other form of beauty so very common.

—*Susan Fenimore Cooper*

*T*o be thrilled by the stars at night; to be elated over a bird's nest, or over a wildflower in spring— these are some of the rewards of the simple life.

—*John Burroughs*

*W*ildflower corners are easy to maintain, but once gone, they are hard to rebuild.

—*Aldo Leopold*

*C*onsider the lilies of the field, how they grow: they neither toil nor spin, yet I tell you, even Solomon in all his glory was not arrayed like one of these.

—*Matthew 6:28–29* (ESV)

*T*o see a world in a grain of sand and a heaven in a wildflower, hold infinity in the palm of your hand and eternity in an hour.

—*William Blake*

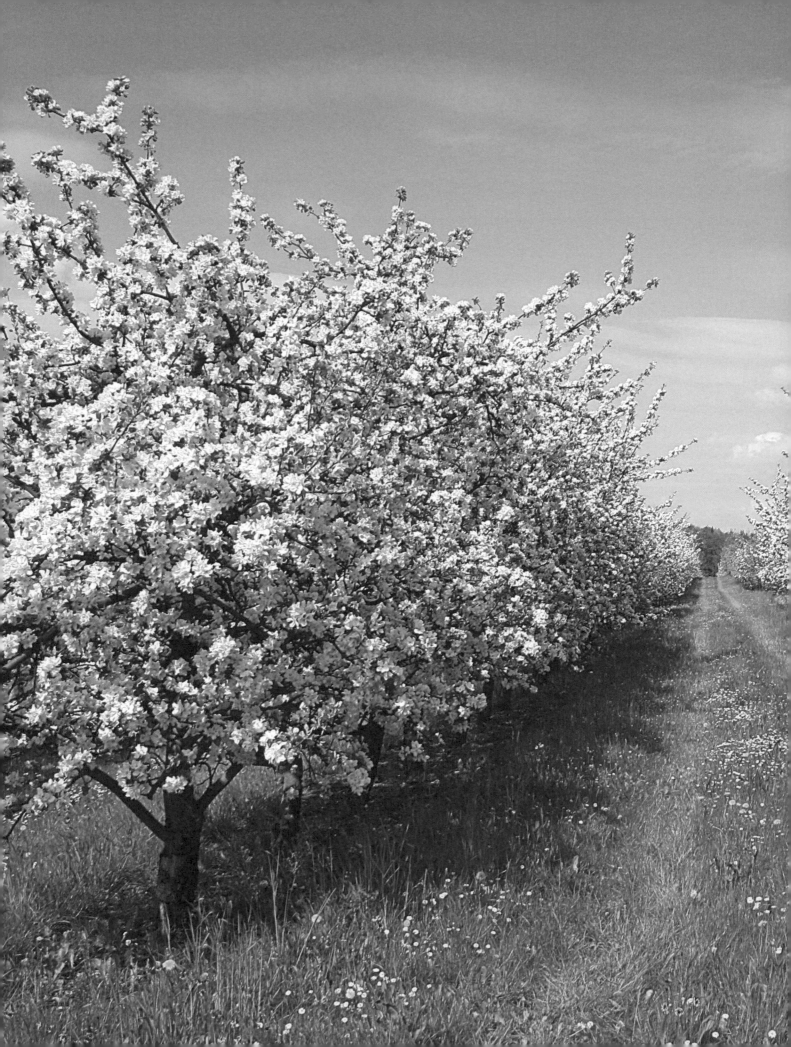

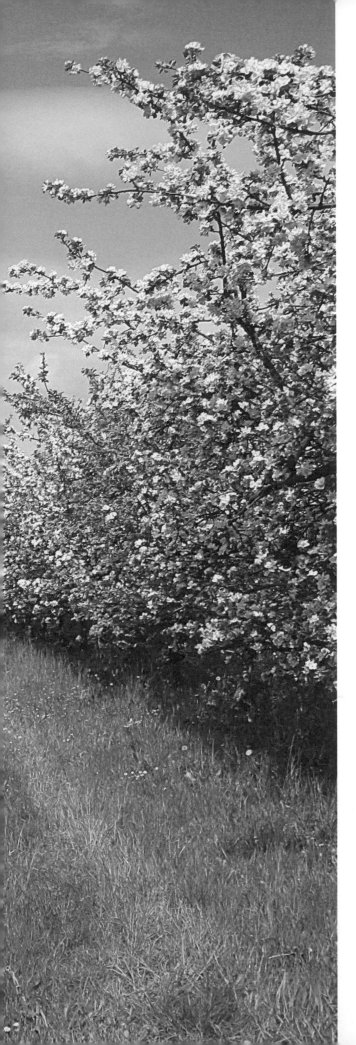

*My troubles are all over, and I am at home;
and often before I am quite awake
I fancy I am still in the orchard
at Birtwick, standing with my
old friends under the apple trees.*
—ANNA SEWELL

Blossom Time

Ellwood Roberts

The scent of apple blossoms
is in the air today;
oh, say, why should we linger,
when green fields call away?
The streets are hot and dusty;
let us no longer stay.

The fields are full of beauty,
the skies ablaze with light;
the dewdrops on the clover
like diamonds gleam in sight,
and earth is kin to heaven,
this morning fresh and bright.

Oh, blessed apple blossoms!
The sweetest time of all
is when to field and orchard
your scent and beauty call;
who hesitates when bidden
to such a festival?

Putting in the Seed
Robert Frost

You come to fetch me from my work tonight
when supper's on the table, and we'll see
if I can leave off burying the white
soft petals fallen from the apple tree
(soft petals, yes, but not so barren quite,
mingled with these, smooth bean and wrinkled pea),
and go along with you ere you lose sight
of what you came for and become like me,
slave to a springtime passion for the earth.
How love burns through the putting in the seed
on through the watching for that early birth
when, just as the soil tarnishes with weed,
the sturdy seedling with arched body comes
shouldering its way and shedding the earth crumbs.

A Touch of Spring
Laverne P. Larson

The mailman brought it yesterday,
that joyous touch of spring,
though winter winds
 are howling
and snow is still on wing.

How eagerly we opened up
that very precious book,
to refresh our spirits once again
with a long and loving look.

All the seeds were pictured there,
like miracles of God,
waiting to be planted
in the wondrous, fertile sod.

The pictures set us dreaming
of gardens, oh, so fair,
of rain and sun and balmy breeze
and days beyond compare.

For us the world was
 dressed in green
as we turned each page to view
that little touch of springtime
that is forever new.

How grateful and how happy
our hearts were yesterday,
to receive that lovely catalog
telling spring is on the way.

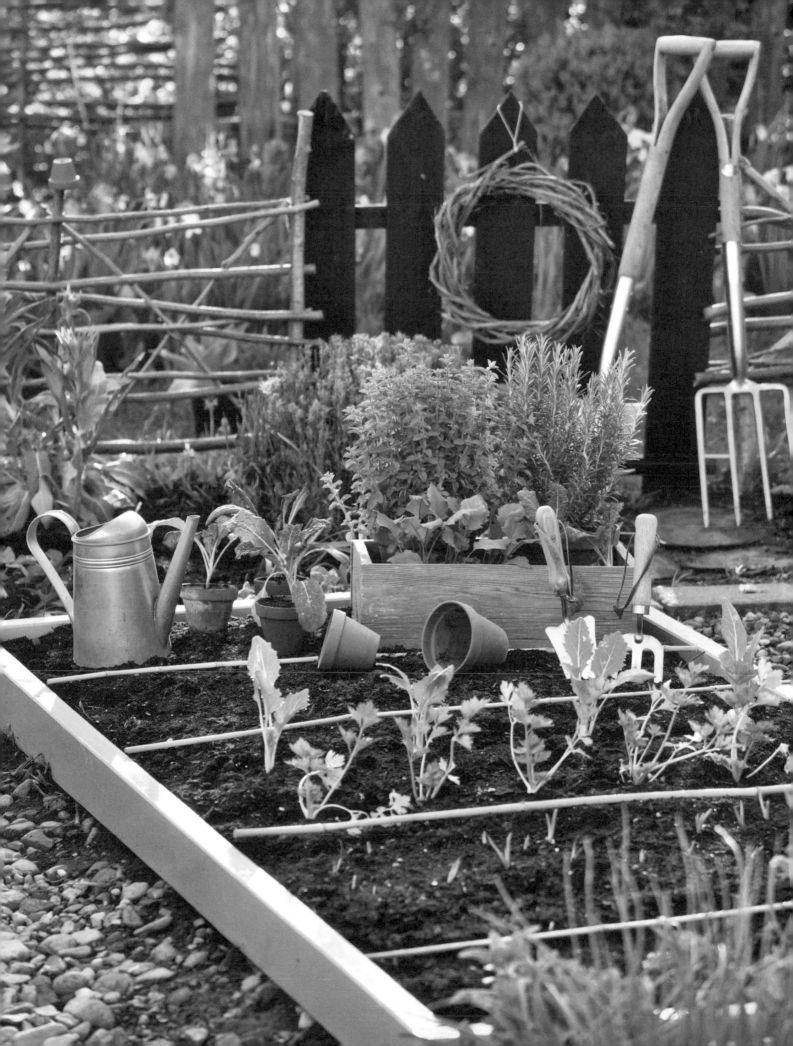

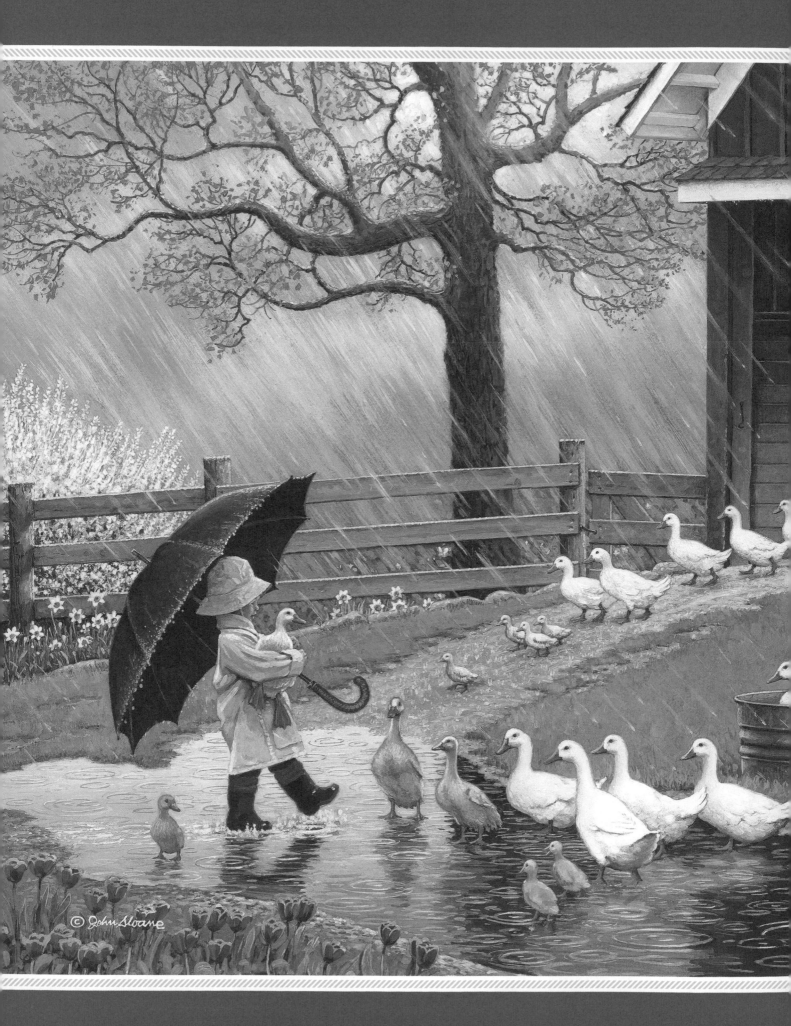

Little Rain

Elizabeth Madox Roberts

When I was making myself a game
up in the garden, a little rain came.
It fell down quick in a sort of rush,
and I crawled back under the snowball bush.

I could hear the big drops hit the ground
and see little puddles of dust fly round.
A chicken came till the rain was gone;
he had just a very few feathers on.

He shivered a little under his skin,
and then he shut his eyeballs in.
Even after the rain had begun to hush,
it kept on raining up in the bush.

One big flat drop came sliding down,
and a ladybug that was red and brown
was up on a little stem waiting there,
and I got some rain in my hair.

Rain

Raymond Garfield Dandridge

The clouds are shedding
 tears of joy;
they fall with rhythmic beat
upon the earth and
 soon destroy
dust dunes and waves of heat.

Each falling drop
 enforcement bears
to river, lake, and rill,
and sweet refreshment
 gladly shares
with wooded dell and hill.

Every flower, bud, and leaf,
 each blossom,
 branch, and tree
distills the rain, 'tis
 my belief,
to feed the honeybee.

I pity every wretch I find
who, frowning in disdain,
is deaf and dumb and
 also blind
to beauty in the rain.

The Return of the Birds

John Burroughs

Spring in our northern climate may fairly be said to extend from the middle of March to the middle of June. At least, the vernal tide continues to rise until the latter date; and it is not till after the summer solstice that the shoots and twigs begin to harden and turn to wood, or the grass to lose any of its freshness and succulency.

It is this period that marks the return of the birds—one or two of the more hardy or half-domesticated species, like the song-sparrow and the bluebird, usually arriving in March, while the rarer and more brilliant wood-birds bring up the procession in June. But each stage of the advancing season gives prominence to the certain species, as to certain flowers. The dandelion tells me when to look for the swallow, the dogtooth violet when to expect the wood thrush; and when I have found the wake-robin in bloom, I know the season is fairly inaugurated. With me this flower is associated, not merely with the awakening of Robin, for he has been awake for some weeks, but with the universal awakening and rehabilitation of nature.

Yet the coming and going of the birds is more or less a mystery and a surprise. We go out in the morning, and no thrush or vireo is to be heard; we go out again, and every tree and grove is musical; yet again, and all is silent. Who saw them come? Who saw them depart?

This pert little winter wren, for instance, darting in and out the fence, diving under the rubbish here and coming up yards away—how does he manage with those little circular wings to compass degrees and zones and arrive always in the nick of time? Last August I saw him in the remotest wilds of the Adirondacks, impatient and inquisitive as usual; a few weeks later, on the Potomac, I was greeted by the same hardy little busybody. Does he travel by easy stages from bush to bush and from wood to wood? Or has that compact little body force and courage to brave the night and the upper air, and so achieve leagues at one pull?

And yonder bluebird with the earth tinge on his breast and the sky tinge on his back—did he come down out of the heaven on that bright March morning when he told us so softly and plaintively that, if we pleased, spring had come? Indeed, there is nothing in the return of the birds more curious and suggestive than in the first appearance, or rumors of the appearance, of this little blue-coat. The bird at first seems a mere wandering voice in the air: one hears its call or carol on some bright March morning, but is uncertain of its source or direction; it falls like a drop of rain when no cloud is visible; one looks and listens, but to no purpose. The weather changes, perhaps a cold snap with snow comes on, and it may be a week before I

hear the note again, and this time or the next perchance see this bird sitting on a stake in the fence lifting his wing as he calls cheerily to his mate. Its notes now become daily more frequent; the birds multiply, and, flitting from point to point, call and warble more confidently and gleefully. Their boldness increases till one sees them hovering with a saucy, inquiring air about barns and outbuildings, peeping into dovecotes and stable windows, inspecting knotholes and pump-trees, intent only on a place to nest. They wage war against robins and wrens, pick quarrels with swallows, and seem to deliberate for days over the policy of taking forcible possession of one of the mud-houses of the latter. But as the season advances they drift more into the background. Schemes of conquest which they at first seemed bent upon are abandoned, and they settle down very quietly in their old quarters in remote stumpy fields.

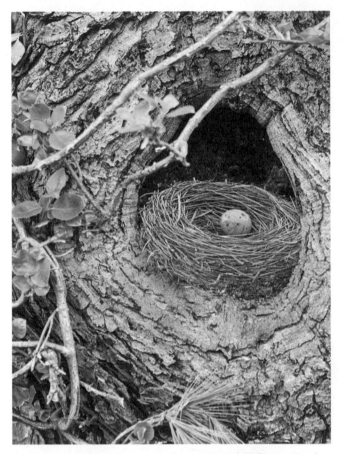

Image © Jil Wellington/Pixabay

Not long after the bluebird comes the robin, sometimes in March, but in most of the northern states, April is the month of the robin. In large numbers they scour the fields and groves. You hear their piping in the meadow, in the pasture, on the hillside. Walk in the woods, and the dry leaves rustle with the whir of their wings; the air is vocal with their cheery call. In excess of joy and vivacity, they run, leap, scream, chase each other through the air, diving and sweeping among the trees with perilous rapidity.

In that free, fascinating, half-work and half-play pursuit, sugar-making, a pursuit which still lingers in many parts of New York, as in New England, the robin is one's constant companion. When the day is sunny and the ground bare, you meet him at all points and hear him at all hours. At sunset, on the tops of the tall maples, with look heavenward, and in a spirit of utter abandonment, he carols his simple strain. And sitting thus amid the stark, silent trees, above the wet, cold earth, with the chill of winter still in the air, there is no fitter or sweeter songster in the whole round year. It is in keeping with the scene and the occasion. How round and genuine the notes are, and how eagerly our ears drink them in! The first utterance, and the spell of winter is thoroughly broken, and the remembrance of it afar off.

The Song-Sparrow

Henry van Dyke

There is a bird I know so well,
it seems as if he must have sung
beside my crib when I was young;
before I knew the way to spell
the name of even the smallest bird,
his gentle, joyful song I heard.
Now see if you can tell, my dear.
What bird it is that, every year,
sings, *"Sweet—sweet—sweet—*
 very merry cheer."

He comes in March, when winds
 are strong,
and snow returns to hide the earth;
but still he warms his
 heart with mirth,
and waits for May. He lingers long
while flowers fade and every day
repeats his small, contented lay;
as if to say, we need not fear
the season's change, if love is here
with *"sweet—sweet—sweet—*
 very merry cheer."

He does not wear a Joseph's-coat
of many colors, smart and gay;
his suit is Quaker brown and gray,
with darker patches at his throat.

And yet of all the well-dressed throng
not one can sing so brave a song;
it makes the pride of looks appear
a vain and foolish thing, to hear
his *"sweet—sweet—sweet—*
 very merry cheer."

A lofty place he does not love,
but sits by choice, and well at ease,
in hedges, and in little trees
that stretch their slender arms above
the meadow-brook; and there he sings
till all the field with pleasure rings;
and so he tells in every ear,
that lowly homes to heaven are near
in *"sweet—sweet—sweet—*
 very merry cheer."

I like the tune, I like the words;
they seem so true, so free from art,
so friendly, and so full of heart,
that if but one of all the birds
could be my comrade everywhere,
my little brother of the air,
I'd choose the song-sparrow, my dear,
because he'd bless me, every year,
with *"sweet—sweet—sweet—*
 very merry cheer."

Lessons from the Nest

Anne Kennedy Brady

I don't mean to brag, but I own a lot of parenting books. I'm familiar with multiple ways to get a newborn to sleep through the night (ha, ha), trick your toddler into eating vegetables, and gently encourage your preschooler to stop submerging her princesses in the guest-room toilet. Then this spring, a family of robins moved onto our back porch, and gradually, I started to look at this parenting gig differently.

In May, my husband and I took an anniversary vacation while my parents watched our kids. One evening, my mother's daily email update held exciting news: "A mama robin built a nest in your ivy planter. You'll have baby birds this spring!"

We returned. My parents went home to Seattle, the kids went to school, and my husband and I followed the bird drama like it was prime time TV. Mama Bird fluffed her feathers and watched us closely but rarely left her post. Then one day, she was nowhere to be found. I peeked gingerly into the nest, and there, nestled in the perfect circle of twigs, were four little balls of fluffy gray feathers! I ran inside to report the news. We watched from the back window as Mama returned to the nest, and four tiny necks shot up, beaks open wide for food.

It became a family ritual to check on the birds each morning. I worried an unseasonably chilly night or a heavy rain would endanger the chicks, but Mama handled it all just fine. Each day she provided exactly what her babies needed—warmth, safety, comfort, food—with that quiet confidence so common in the animal world. I thought about raising my own kiddos. Amidst a slew of advice and opinions, I have felt almost constantly overwhelmed since day one. But here was a mama who followed zero parenting influencers, and she did just fine. Her family needed only her presence, and so, I suspected, did mine.

The baby birds grew, school days dwindled, and my son and daughter brought home end-of-year folders. Flipping through Milo's first-grade writing exercises, I watched his penmanship evolve from unreadable to only occasionally cryptic. Helen's preschool scribbles gradually coalesced into smiley faces and a wobbly letter H. I glanced at our back porch nest. The baby birds looked less fragile now. Mama Bird left the nest for longer periods each day, but still stopped by regularly with snacks (always with the snacks). Each night she faithfully returned, though the kids's cuddly pile had grown so large that Mama didn't so much nestle as perch precariously. Beaks prodded her belly, and stretching wings threatened to topple her; and yet here we both remained in our strange and shifting roles.

Then one day, one of the babies stretched its wings! I called my husband over and we held our breath as it tottered on the edge of the planter. "Where's its mama?" my husband asked, affronted. At just that moment she fluttered over and landed next to her bold young fledgling. She cocked her head, then flew up to a nearby branch. The baby hopped and wobbled, before Mama flew back for another lesson. We watched, rapt, until finally, cautiously, baby took off. We

cheered like this bird was Charles Lindbergh. "It's like she just knew!" I marveled. "She came back at exactly the right time." My husband squeezed my hand. "Yeah. Good moms are always there when their kids need them."

A couple of weeks later, I took the kids to visit my parents on the West Coast. In the car ride from the airport, I told my mom about the final bird to leave the nest. We had come out one morning to find this little one alone, perched on the deck furniture just below the nest. It was cold and rainy and he seemed to shiver. We worried he'd been left to fend for himself. After a few moments, Mama landed beside him, dropped off a snack, and took off again. We couldn't believe it! He tried again throughout the day, landing on a nearby fence, our front patio, and the metal

fire escape. Each time, his mama found him and brought him food. I told Mom I was surprised that even though this little bird had left home, his mama still found and cared for him.

Then Milo, who is always listening, chirped from the backseat, "Mama, would you still love us if you couldn't see us?" I glanced at my own mama, who shot me a knowing smile. We haven't lived in the same city since I graduated from high school, and I now live seventeen hundred miles away. Yet, whom do I call whenever I'm worried or working through a problem or bursting with good news? I smiled and swallowed hard. "Yes, Milo," I replied. "No matter where you are, I will always be there for you."

"Good," he said, settling back into his seat. "Do you have any snacks?"

When I Was Six

Frances Bowles

When I was only six, my dear,
and orchards were in bloom,
I used to look for Easter eggs
in every place and room.

When I was only six, my dear,
I searched from east to west
until I found some Easter eggs
hidden in a rabbit's nest.

The rabbit still lingered there,
and it had left for me

some bright and shining colored eggs
beneath a snow-white tree.

Now that I am no longer six,
I journey back each spring
to find the rabbit's cozy nest
and hear a robin sing.

And there again I find the eggs
of red and green and blue,
and once again I keep the faith
of Eastertime—don't you?

Easter Eggs

Mary A. Erb

I gather the eggs each day for my mama
wherever an egg can be found,
in the nests in the hen house,
 the cow shed and manger,
and sometimes there's one
 on the ground.

I climb to the hayloft and hunt in
 the corners
where the old biddies hide them away;
snuggled back in a nest
 where no one can see them,
they lay them up there in the hay.

I follow the turkeys
 way down to the meadows
where they think that no one will go;
but wherever they hide them,
 I always can find them,
their cute tricks I every one know.

But hunt as I will, it is
 only at Easter
the nest of the rabbit I find,
with its eggs many colored,
 blue, green, red, and yellow—
the best of all eggs, to my mind.

Image © ShunTerra/Adobe Stock

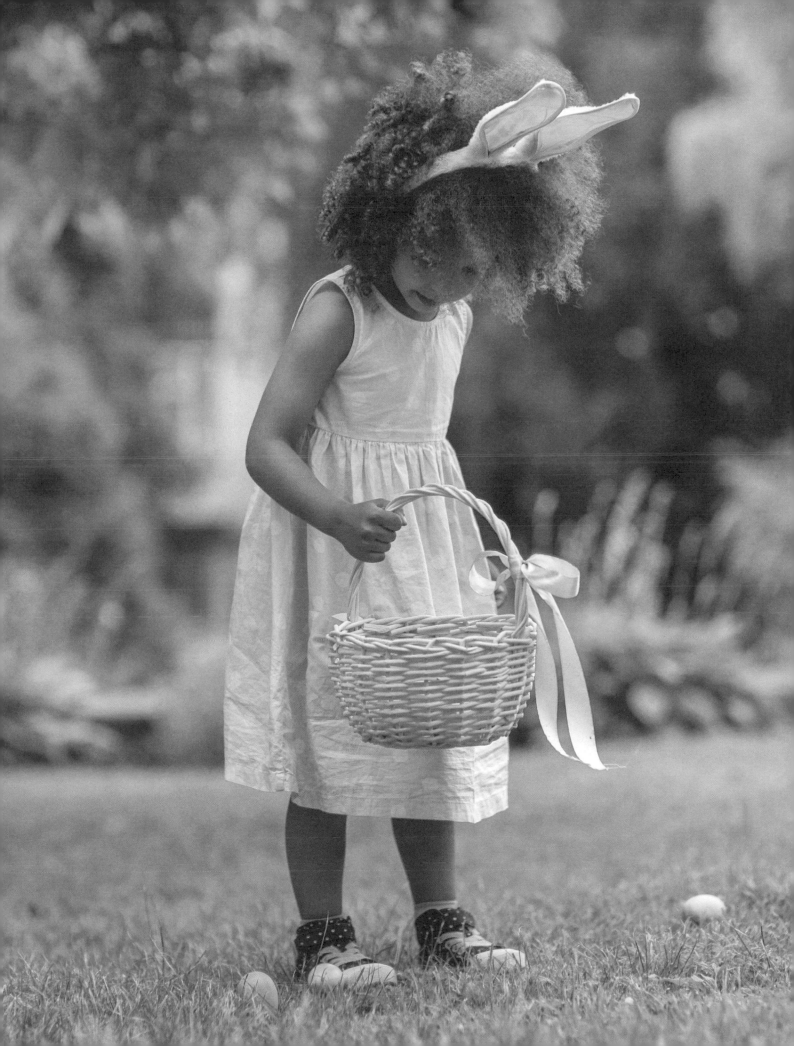

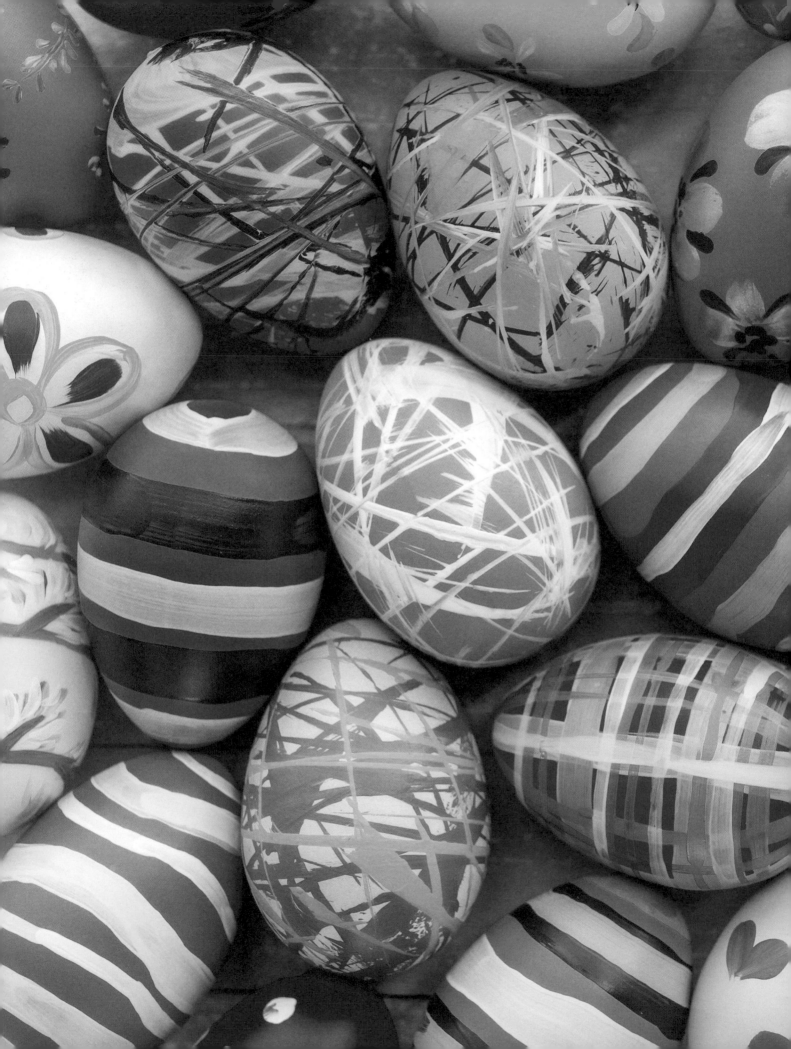

Easter Treasures
Linda C. Grazulis

These oval treasures seem so small and tiny,
but cherished by one and all.
What excitement and anticipation await us
with that carton of eggs we saw!
Every Easter makes us joyful, chuckling children
as to the kitchen we peek and see
those simple, gem-like treasures created
by ourselves, friends, and family.
What a sparkle twinkles from the eye
as we encounter another Easter to design
a work of art.
Reach for an egg, imagine the possibilities
as a rainbow of colors glow and glisten
within the heart!

It's Easter Again
Rebecca Barlow Jordan

No Easter celebration
was complete without
the hunt—
with plastic, boiled, or candy eggs
prepared for children's fun.
We dyed a few with stripes
and spots,
filled plastic ones with candy;
then to cushion every basket,
we kept colored grasses handy.
We pulled one plastic egg aside,
only filled with air.
The hollow shell of emptiness,
(nothing more, no candy there)
would symbolize the empty tomb
on Easter long ago—
a way to share with
little hearts
so they could also know
the reason for our happiness,
with no hesitation:
the story of the very first
Easter celebration.
Then, with everything
prepared,
we let the hunt begin.
Let's celebrate with
happy hearts:
It's Eastertime again!

Faith

Marion Weaver

"I don't believe," I've heard it said
by those whose faith is nil.
Could they be blind to April
that blossoms on the hill?

Our faith in resurrection
is the dearest thing on earth;
the miracle of springtime,
each year, a new rebirth.

The magic of a flower
blooming from the winter sod—
how can they look at springtime
and not believe in God?

He Walks with You

Susan Sundwall

When He walked through
 the lily fields
He thought of you.
With gentle hands
He shaped the wood
and heard your prayers.
While preaching to
 the multitudes,
your face He knew
and in the shadowed
 valley of death,
you were in His tears.
In every hour of your day,
in sorrow and joy,
He walks beside you.

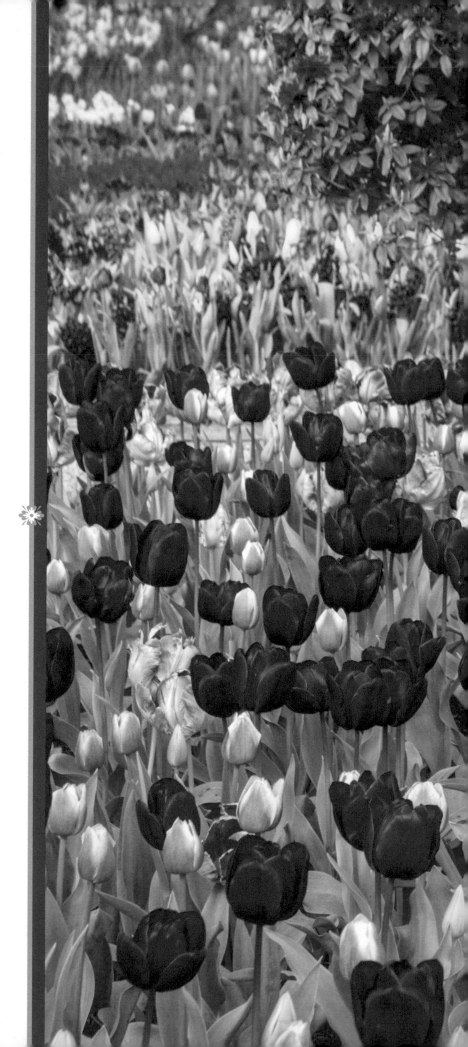

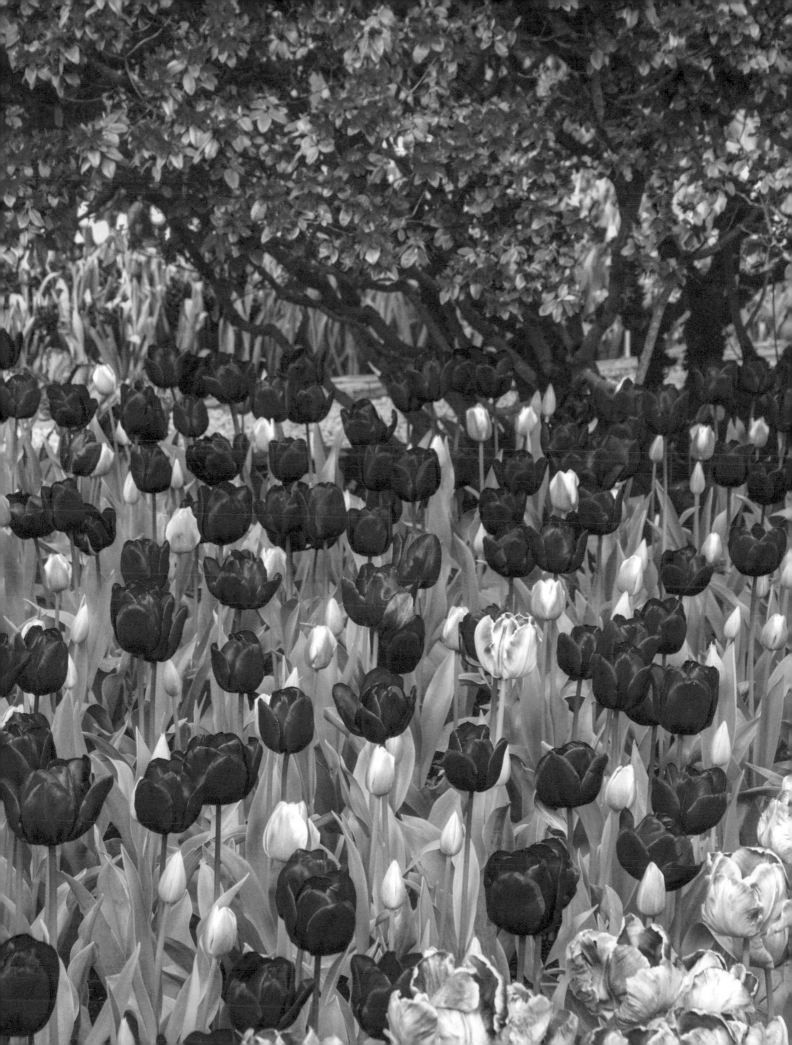

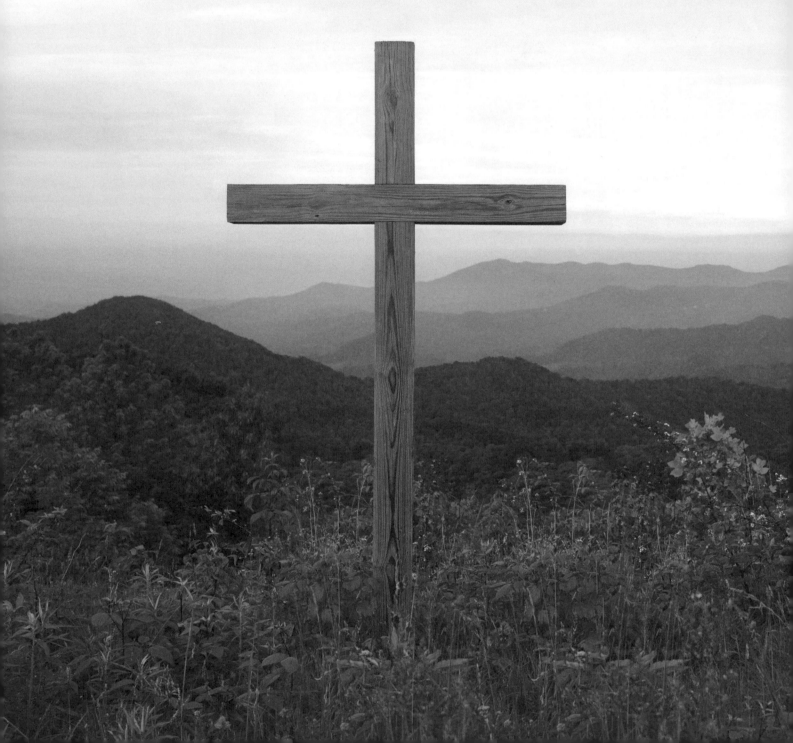

His Crucifixion

John Bowring

When the woes of life o'ertake me,
hopes deceive, and fears annoy,
never shall the cross forsake me.
Lo! it glows with peace and joy.

When the sun of bliss is beaming
light and love upon my way,
from the cross the radiance streaming
adds new luster to the day.

Bane and blessing, pain and pleasure,
by the cross are sanctified;
peace is there that knows no measure,
joys that through all time abide.

Man of Sorrows

Philip P. Bliss

Man of Sorrows, what a name
for the Son of God, who came
ruined sinners to reclaim.
Hallelujah! What a Savior!

Bearing shame and scoffing rude,
in my place condemned He stood,
sealed my pardon with His blood.
Hallelujah! What a Savior!

Guilty, vile, and helpless we;
spotless Lamb of God was He;

"full atonement!"—can it be?
Hallelujah! What a Savior!

Lifted up was He to die;
"It is finished!" was His cry;
now in Heav'n exalted high.
Hallelujah! What a Savior!

When He comes, our glorious King,
all His ransomed home to bring,
then anew His song we'll sing:
Hallelujah! What a Savior!

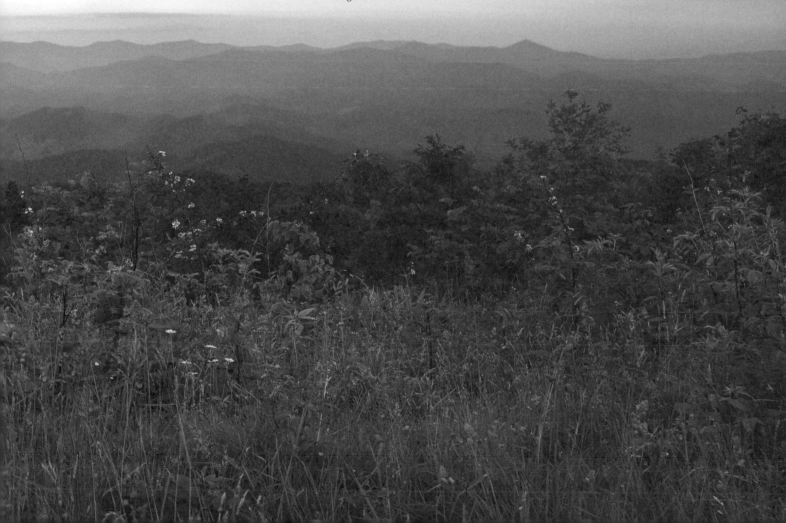

The Triumphal Entry
Matthew 20:29–34; 21:1–11 (ESV)

Rejoice greatly, O daughter of Zion! Shout aloud, O daughter of Jerusalem!
Behold, your king is coming to you; righteous and having salvation is he, humble and mounted
on a donkey, on a colt, the foal of a donkey. —ZECHARIAH 9:9 (ESV)

And as they went out of Jericho, a great crowd followed him. And behold, there were two blind men sitting by the roadside, and when they heard that Jesus was passing by, they cried out, "Lord, have mercy on us, Son of David!" The crowd rebuked them, telling them to be silent, but they cried out all the more, "Lord, have mercy on us, Son of David!" And stopping, Jesus called them and said, "What do you want me to do for you?" They said to him, "Lord, let our eyes be opened." And Jesus in pity touched their eyes, and immediately they recovered their sight and followed him.

Now when they drew near to Jerusalem and came to Bethpage, to the Mount of Olives, then Jesus sent two disciples, saying to them, "Go into the village in front of you, and immediately you will find a donkey tied, and a colt with her. Untie them and bring them to me. If anyone says anything to you, you shall say, 'The Lord needs them,' and he will send them at once." This took place to fulfill what was spoken by the prophet saying, "Say to the daughter of Zion, 'Behold, your king is coming to you, humble, and mounted on a donkey, on a colt, the foal of a beast of burden.'"

The disciples went and did as Jesus had directed them. They brought the donkey and the colt and put on them their cloaks, and he sat on them. Most of the crowd spread their cloaks on the road, and others cut branches from the trees and spread them on the road. And the crowds that went before him and that followed him were shouting, "Hosanna to the Son of David! Blessed is he who comes in the name of the Lord! Hosanna in the highest!" And when he entered Jerusalem, the whole city was stirred up, saying, "Who is this?" And the crowds said, "This is the prophet Jesus, from Nazareth of Galilee."

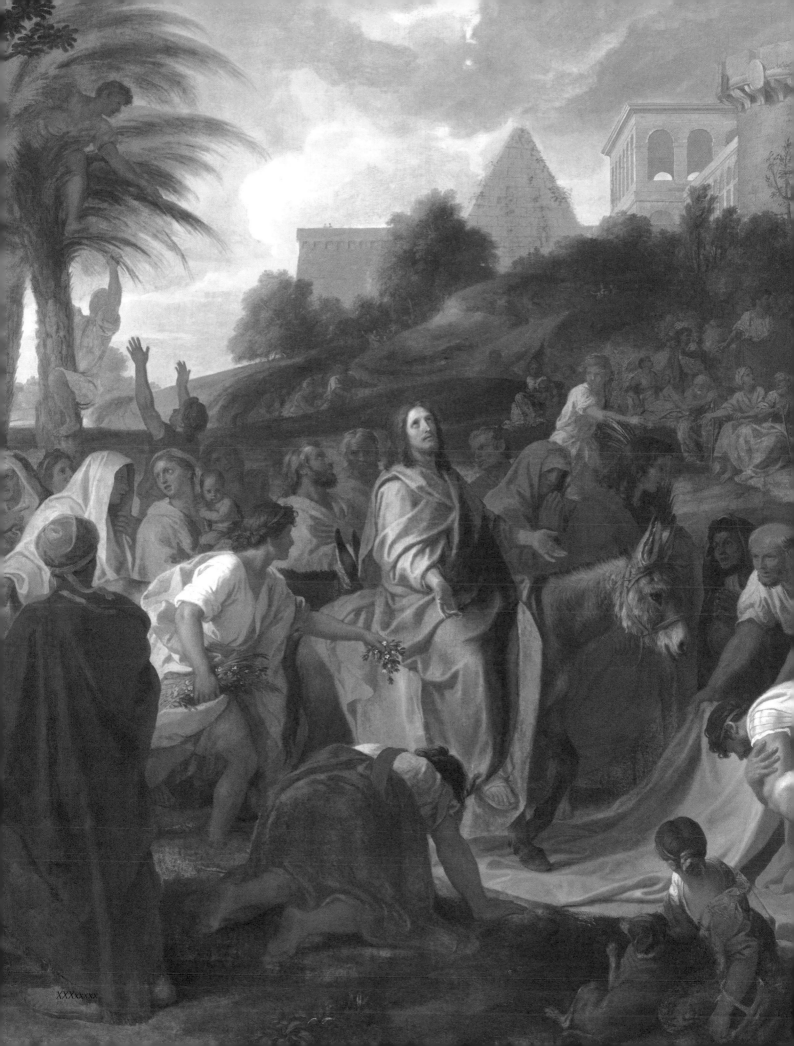

XXXxxxxx

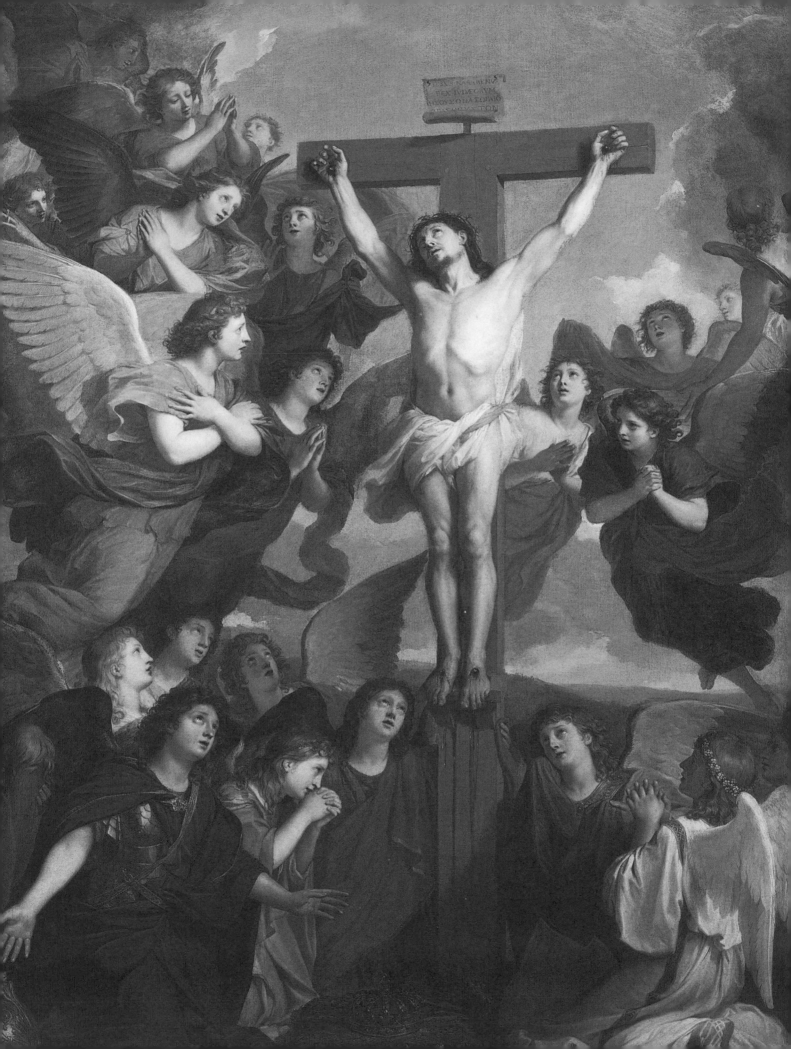

The Crucifixion

Luke 22:19–20, 39; Matthew 26:45–47; 27:1–2; Mark 15:22, 24–25, 33–34, 37–39 (ESV)

Behold, the days are coming, declares the LORD, when I will make a new covenant . . .
not like the covenant that I made with their fathers on the day when I took them by the hand
to bring them out of the land of Egypt . . . declares the LORD. — JEREMIAH 31:31–32 (ESV)

And he took bread, and when he had given thanks, he broke it and gave it to them, saying, "This is my body, which is given for you. Do this in remembrance of me." And likewise the cup after they had eaten, saying, "This cup that is poured out for you is the new covenant in my blood." . . . And he came out and went, as was his custom, to the Mount of Olives, and the disciples followed him.

Then he came to the disciples and said to them, "Sleep and take your rest later on. See, the hour is at hand, and the Son of Man is betrayed into the hands of sinners. Rise, let us be going; see, my betrayer is at hand." While he was still speaking, Judas came, one of the twelve, and with him a great crowd with swords and clubs, from the chief priests and the elders of the people.

When morning came, all the chief priests and the elders of the people took counsel against Jesus to put him to death. And they bound him and led him away and delivered him over to Pilate the governor.

And they brought him to the place called Golgotha (which means Place of a Skull). . . . And they crucified him and divided his garments among them, casting lots for them, to decide what each should take. And it was the third hour when they crucified him. . . . And when the sixth hour had come, there was darkness over the whole land until the ninth hour. And at the ninth hour Jesus cried with a loud voice, *"Eloi, Eloi, lema sabachthani?"* which means, "My God, my God, why have you forsaken me?" . . . And Jesus uttered a loud cry and breathed his last. And the curtain of the temple was torn in two, from top to bottom. And when the centurion, who stood facing him, saw that in this way he breathed his last, he said, "Truly this man was the Son of God!"

THE CRUCIFIX WITH ANGELS *by Charles Le Brun. Image © DeAgostini/SuperStock.*

The Resurrection and Ascension

Mark 16:1–16, 19 (ESV)

And as Jesus was going up to Jerusalem, he took the twelve disciples aside, and on the way he said to them, ". . . the Son of Man will be delivered over to the chief priests and scribes, and they will condemn him to death and deliver him over to the Gentiles to be mocked and flogged and crucified, and he will be raised on the third day." —MATTHEW 20:17–19 (ESV)

When the Sabbath was past, Mary Magdalene, Mary the mother of James, and Salome bought spices, so that they might go and anoint him. And very early on the first day of the week, when the sun had risen, they went to the tomb. And they were saying to one another, "Who will roll away the stone for us from the entrance of the tomb?" And looking up, they saw that the stone had been rolled back—it was very large. And entering the tomb, they saw a young man sitting on the right side, dressed in a white robe, and they were alarmed. And he said to them, "Do not be alarmed. You seek Jesus of Nazareth, who was crucified. He has risen; he is not here. See the place where they laid him. But go, tell his disciples and Peter that he is going before you to Galilee. There you will see him, just as he told you." And they went out and fled from the tomb, for trembling and astonishment had seized them, and they said nothing to anyone, for they were afraid.

Now when he rose early on the first day of the week, he appeared first to Mary Magdalene, from whom he had cast out seven demons. She went and told those who had been with him, as they mourned and wept. But when they heard that he was alive and had been seen by her, they would not believe it. After these things he appeared in another form to two of them, as they were walking into the country. And they went back and told the rest, but they did not believe them.

Afterward he appeared to the eleven themselves as they were reclining at table, and he rebuked them for their unbelief and hardness of heart, because they had not believed those who saw him after he had risen. And he said to them, "Go into all the world and proclaim the gospel to the whole creation. Whoever believes and is baptized will be saved, but whoever does not believe will be condemned." . . . So then the Lord Jesus, after he had spoken to them, was taken up into heaven and sat down at the right hand of God.

THE THREE MARYS AT THE EMPTY SEPULCHRE by Baciccio. Image © Fitzwilliam Museum, Cambridge/Art Resource, NY.

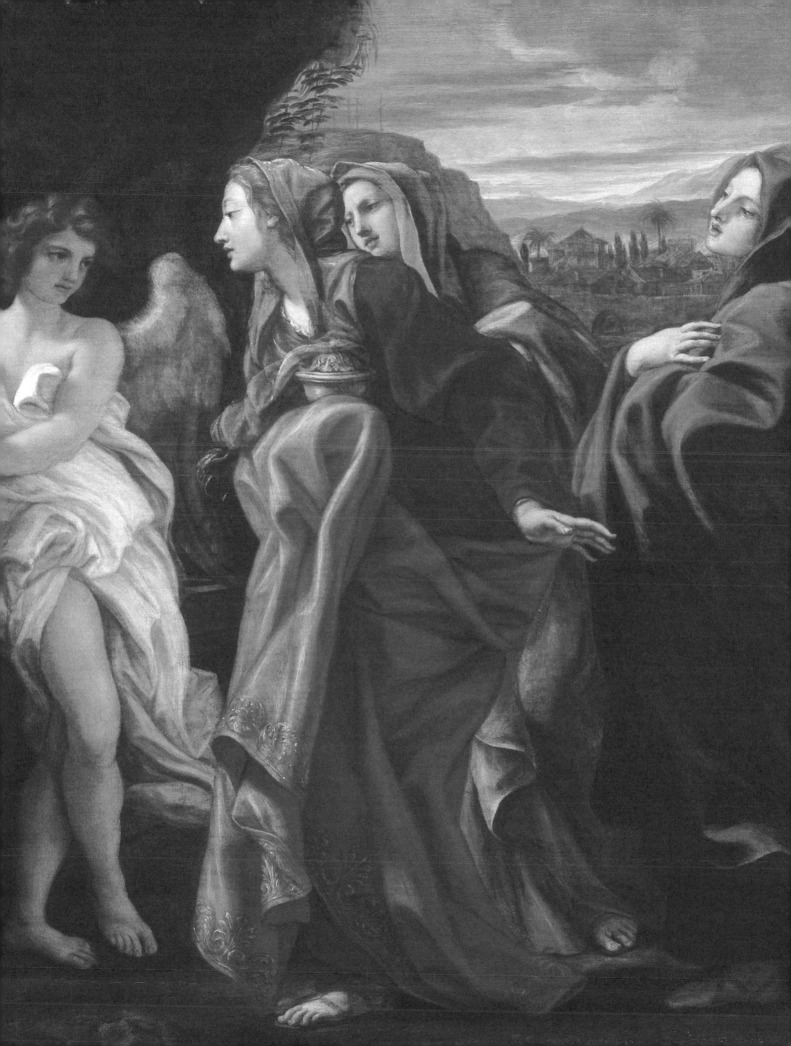

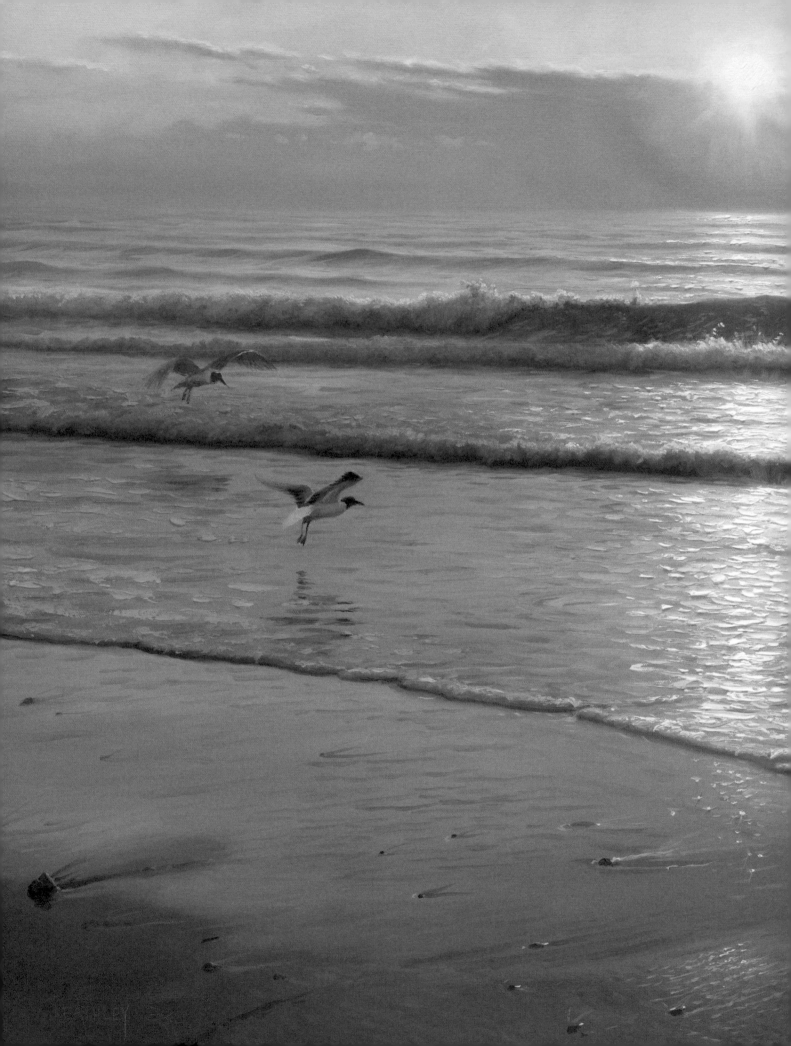

My Lord, What a Morning!

African American Spiritual

My Lord, what a morning,
my Lord, what a morning,
my Lord, what a morning
when the stars begin to fall.

You'll hear the
 trumpet sound
to wake the nations
 underground,
looking to my God's
 right hand
when the stars begin to fall.

My Lord, what a morning,
my Lord, what a morning,
my Lord, what a morning
when the stars begin to fall.

You'll hear the sinner mourn
to wake the nations
 underground,
looking to my God's
 right hand
when the stars begin to fall.

My Lord, what a morning,
my Lord, what a morning,
my Lord, what a morning
when the stars begin to fall.

You'll hear the
 Christian shout
to wake the nations
 underground,
looking to my God's
 right hand
when the stars begin to fall.

My Lord, what a morning,
my Lord, what a morning,
my Lord, what a morning
when the stars begin to fall.

The Day of Resurrection

John of Damascus

The day of Resurrection!
Earth, tell it out abroad;
the Passover of gladness,
the Passover of God:
From death to life eternal,
from earth unto the sky,
our Christ hath brought us over
with hymns of victory.

Our hearts be pure from evil,
that we may see aright
the Lord in rays eternal
of resurrection light,
and, listening to His accents,
may hear, so calm and plain,
His own "All hail!" and, hearing,
may raise the victor strain.

Now let the heav'ns be joyful,
let earth her song begin;
let the round world keep triumph
and all that is therein:
invisible and visible,
their notes let all things blend,
for Christ the Lord hath risen,
our joy that hath no end.

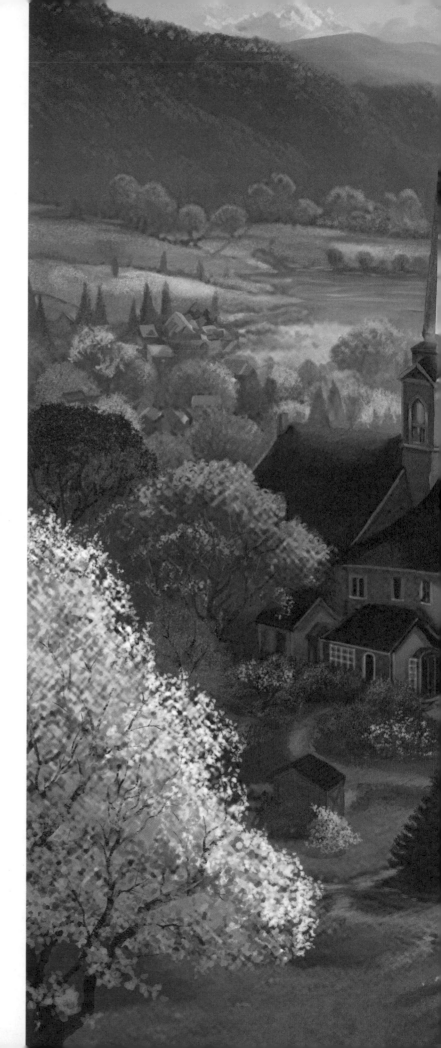

SPRING VALLEY *by Bigelow Illustrations.*
Image © Bigelow Illustrations/Art Licensing

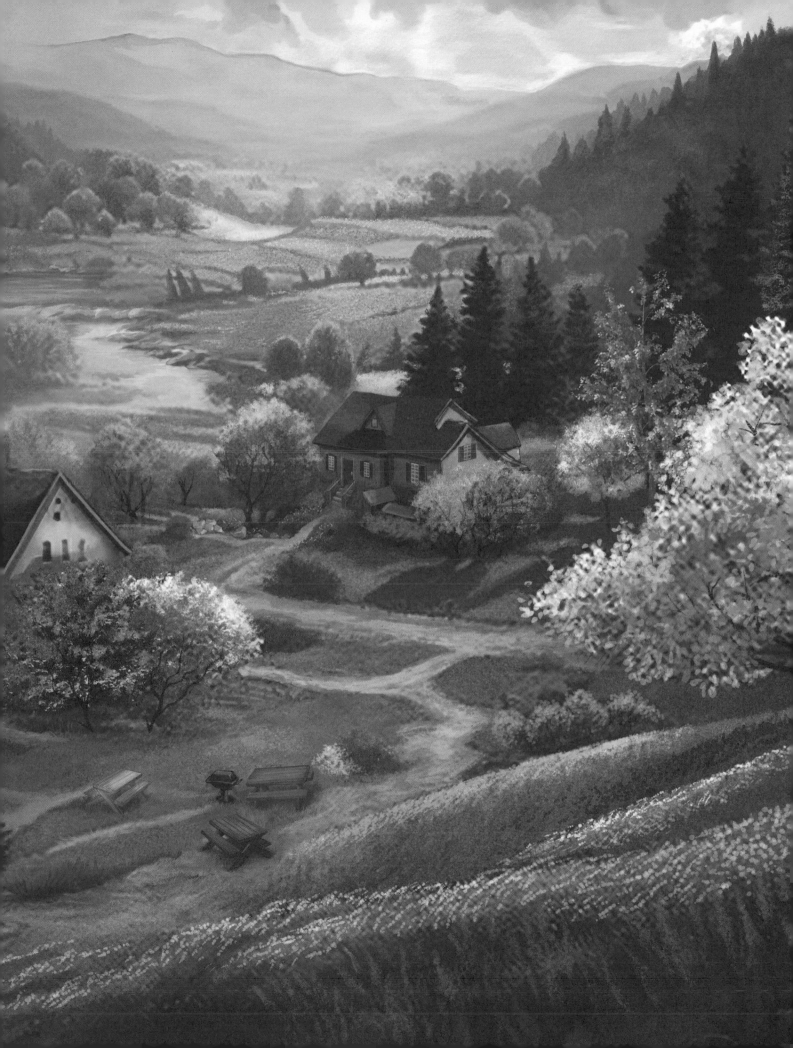

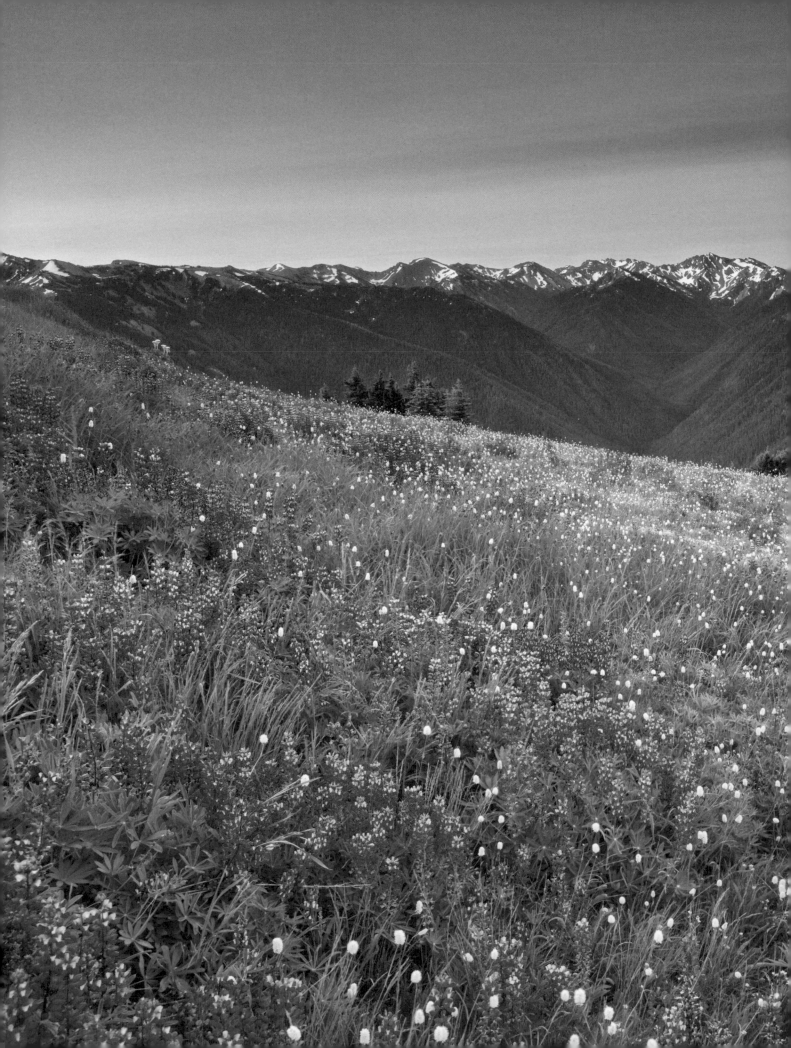

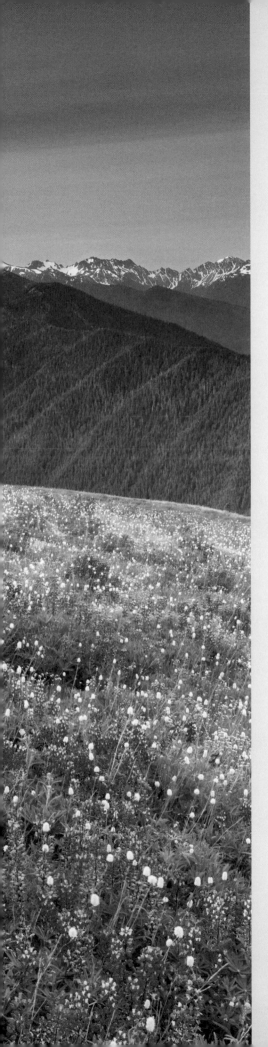

Welcome, Happy Morning
Georgia M. Emmert

The purple dawn came
 o'er the hill
and knelt in love to pray;
she hung her silver
 on the cross
and sang, "It's Easter Day!"

I, too, came up a lonely hill
and knelt in love to pray;

I hung my burdens
 on the cross
and sang, "It's Easter Day!"
It's Easter Day,
 it's Easter Day!

Lord, grant that we may see
the vision of Thy loveliness
and build our lives on Thee.

An Easter Song
Susan Coolidge

A song of sunshine through
 the rain,
of spring across the snow,
a balm to heal the hurts
 of pain,
a peace surpassing woe.
Lift up your heads, ye
 sorrowing ones,
and be ye glad of heart,
for Calvary and Easter Day,
earth's saddest day and
 gladdest day,
were just one day apart!

With shudder of despair
 and loss,
the world's deep heart
 was wrung,
as lifted high upon His cross
the Lord of Glory hung,
when rocks were rent,
 ghostly forms
stole forth in street and mart;
but Calvary and Easter Day,
earth's saddest day and
 gladdest day,
were just one day apart!

Olympic National Park. Image © Dennis Frates

Through My Window

An Easter of Small Things

Pamela Kennedy

We have celebrated many Easters as members of a large church where the services were magnificent. A choir of nearly one hundred, accompanied by a full orchestra, filled the sanctuary with glorious renditions of "Christ the Lord Has Risen Today!" and Handel's "Hallelujah Chorus." Bells rang, cymbals crashed, and the pipe organ thrilled us as we envisioned the triumphant victory of the Resurrection. Goosebumps were a regular feature.

A year ago, we moved our membership to a much smaller church. It was closer to where we lived and afforded us the opportunity to be more involved within our local community. The Easter service was much simpler, with a choir of about a dozen members and a string quartet. The congregation, closer to a hundred than a thousand, sang the familiar Easter hymns, read the Easter story from the Bible, and prayed together under morning light streaming through tall stained-glass windows. It was also a holy experience.

I noticed, in the days after Easter, how my attention was captured by little harbingers of the coming season. Plump buds appeared on dead-looking branches. Tiny crocuses pushed up through cold, dark earth. Songbirds hopped in still-bare trees. Resurrection was happening slowly, in quiet and tiny ways. Breezes gradually lost their frigid edges and swirled around me carrying scents of damp soil, newly emerging grasses, and the promise of spring.

Somehow, enraptured in the past by grandeur and glory, I think I overlooked the small ways that Easter also speaks its truth. In that garden, two millennia ago, there were no trumpets or angel choirs singing. There were just a few women from Jerusalem, come to minister to their dead friend. They approached the rocky tomb, not with cymbals and stringed instruments, but with fear and trepidation, carrying burial spices, in the pale light of the sunrise. What they discovered there, although amazing, was also puzzling and unsettling. And when they ran to share their discovery, they were doubted and dismissed. They were insignificant players in their society.

That first Easter took place in a small part of the world to a small number of people who were not considered to be important in the larger scheme of the Roman empire. Yet, within a few years, the message first spoken that morning would capture the minds and hearts of thousands, then millions of people. Eventually it would spread, through centuries, to all parts of the earth, to continents far away, to generations not even dreamed

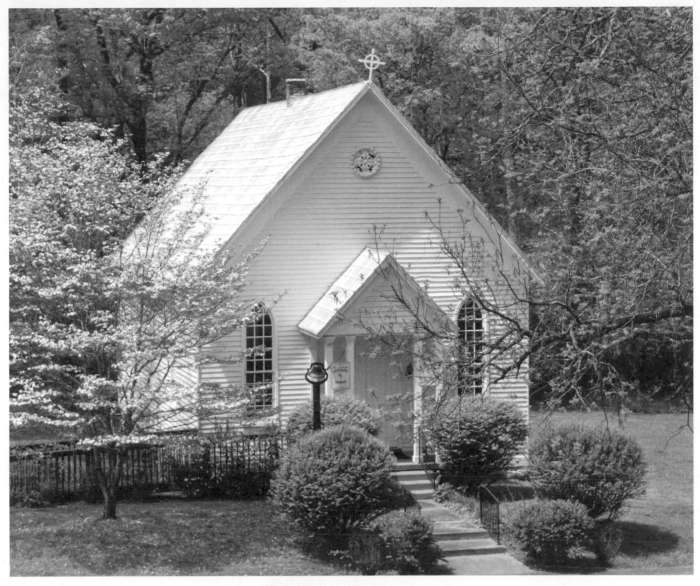

Image © Robin Zeigler/iStock

of. Symphonies and sonnets would be composed, books written, sculptures and paintings created, cathedrals built, and institutions transformed by the seeds sown in that little garden.

This spring as I again anticipate Easter, I want to be intentional about noticing the small things, not only in nature, but also in the people around me. To be aware of the glimmer of fear in the eye of a friend and respond with care. To see the uncertainty in the face of a child as she learns a new skill or takes a risk to make a new friend. To sit with patience when a neighbor needs silence to process unsettling news. To appreciate small gestures of kindness and notice opportunities to nurture fragile hopes. Life is filled with so many small things just waiting for my attention. I believe that's the message of Easter that I need to hear now more than ever. In a world filled with huge issues clamoring for my attention, this Easter I will choose to focus on the small things all around me that truly need to be noticed. And then I will trust that the mystery of resurrection power, first born in a Jerusalem garden tomb yet still available today, will nurture those small things to blossom and grow as God intends.

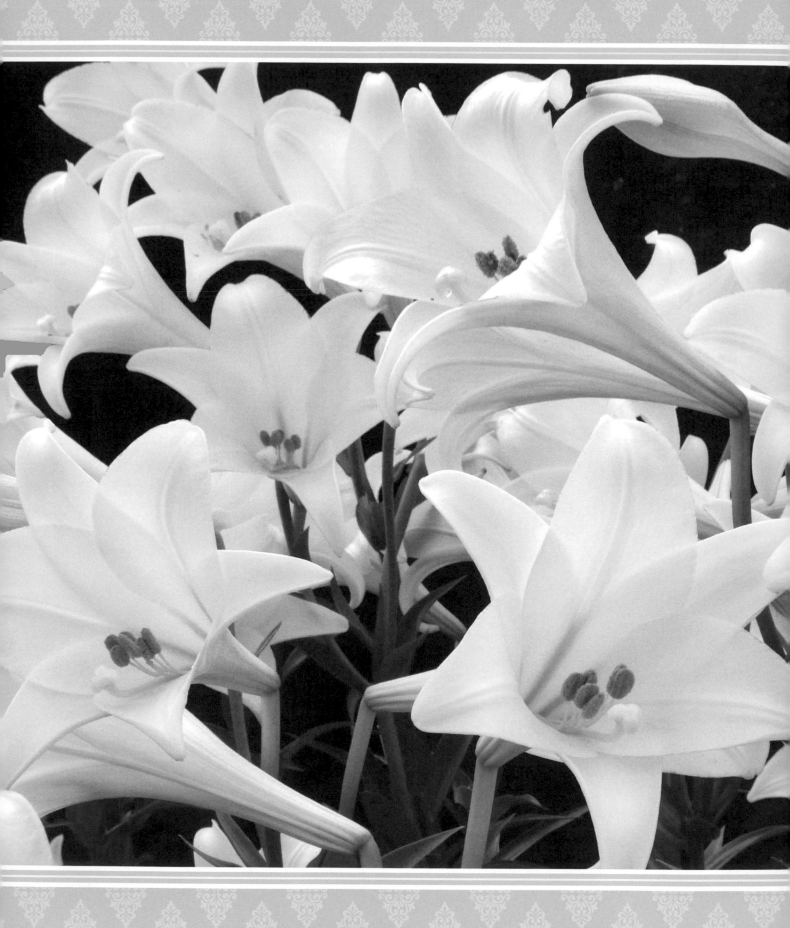

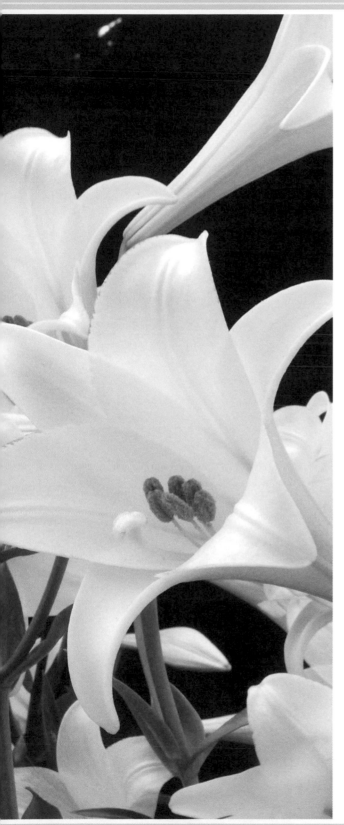

Consider the Lilies

Charlotte Murray

O lilies fair, O emblems meet
of Easter, and its bliss,
with angel-hands ye point us on
to higher life than this;
ye tell us of a Savior's love
which prompted Him to die
that He might manifest to us
a better world on high.

Easter lilies, fresh and fair,
we welcome you again,
as stars of hope to lead us on
through sorrow's night of pain;
by you the Spirit speaks to those
who will the message hear
of resurrection power and love,
in this the wakening year.

The modest rose puts forth a thorn,
the humble sheep, a threat'ning horn:
while the lily white
shall in love delight,
nor a thorn, nor a threat,
stain her beauty bright.
—WILLIAM BLAKE

Image © ginahsu/Adobe Stock

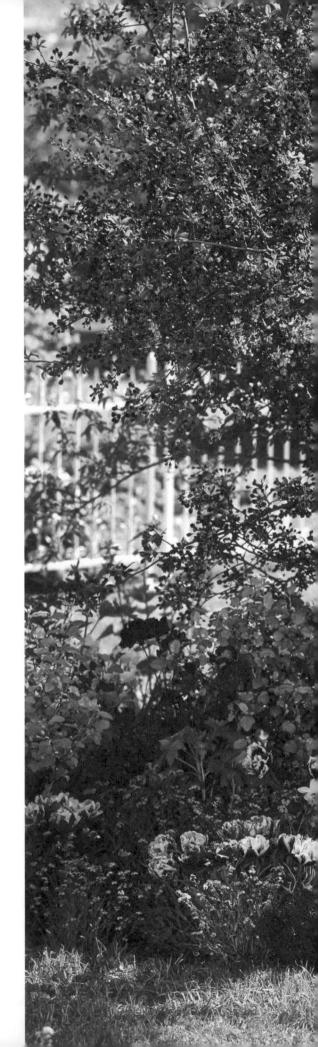

We Thank Thee

Peter Marshall

We thank Thee for the beauty of this day, for the glorious message that all nature proclaims: the Easter lilies with their waxen throats eloquently singing the good news; the birds, so early this morning, impatient to get in their song; every flowering tree, shrub, and flaming bush, a living proclamation from Thee. O open our hearts that we may hear it too!

Lead us, we pray Thee, to the grave that is empty, into the garden of the Resurrection where we may meet our risen Lord. May we never again live as if Thou were dead!

> In Thy presence restore our faith,
> our hope, our joy.
> Grant to our spirits refreshment,
> rest, and peace.
> Maintain within our hearts an
> unruffled calm, an unbroken serenity
> that no storms of life shall ever
> be able to take from us.

From this moment, O living Christ, we ask Thee to go with us wherever we go; be our Companion in all that we do. And for this greatest of all gifts, we offer Thee our sacrifices of thanksgiving. Amen.

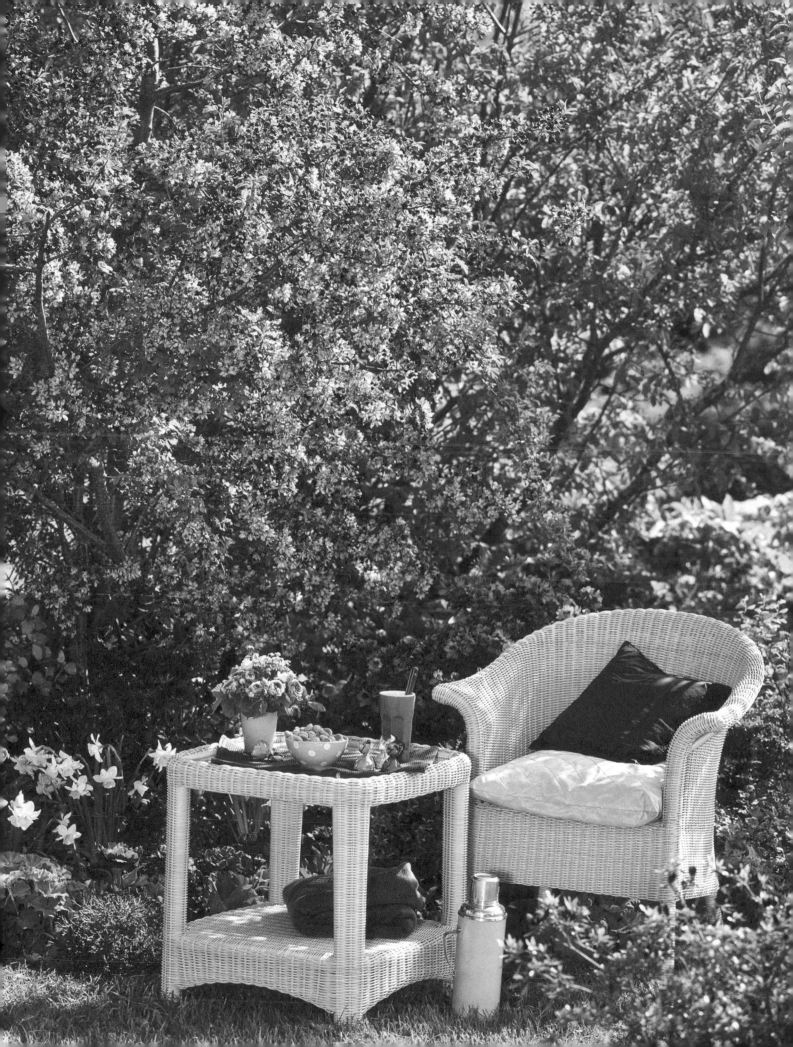

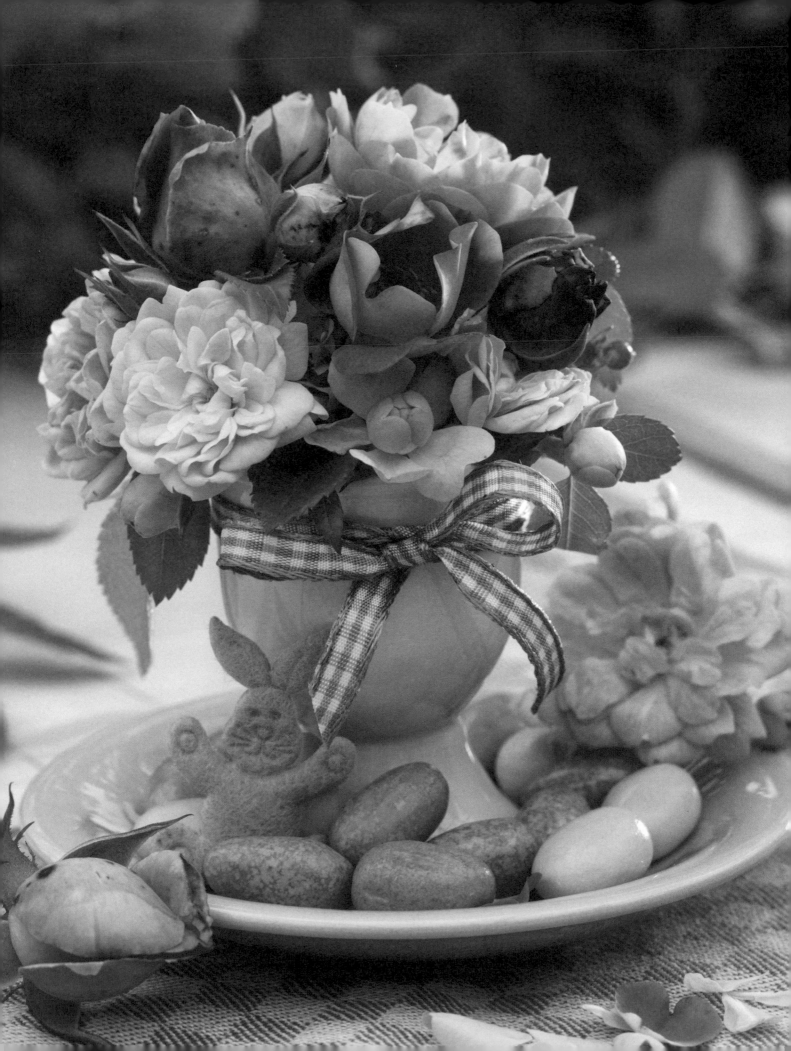

Easter Dinner

Holly Harden

Made stuffed mushrooms on Saturday, and they were pretty good. I kept leaving the kitchen to sneak a jellybean or two from the bowl on the coffee table. I had eaten all the black ones already, and white was my next target, and I noticed my daughter watching as I popped one into my mouth.

"I didn't know you like jellybeans so much, Mom," she said, and I replied that it is more of a nostalgia thing for me to eat them. I buy them only once a year, the full-sized sugary ones, and I suppose I eat most of them. The kids aren't much interested. They have Peeps to eat, and solid chocolate rabbits. They have mini candy bars and Tootsie pops and strange, colorful little things that fizz in your mouth.

One black jellybean is all I need to transport myself back to the basement fellowship hall of the Lutheran church of my girlhood, where on Easter Sunday there was a service at sunrise, followed by a breakfast of egg bake, sausage, cheesy hash browns, cinnamon rolls, coffee, and orange juice. And next to each plate in a little paper cup was a modest pile of jellybeans. My brothers and I ate them throughout the meal and helped clean up after, on the off-chance that we'd be given leftover jellybeans, which we often were.

It wasn't the meal or the service or the array of lilies round the cross or the organ playing or the pastel dresses or hats or anything in particular that made those Easter Sundays memorable. It was all of it together. Getting up early, the hunt for candy, the fight for the bathroom mirror, the walk to church, my father dozing off during the sermon, the smell of my mother's skin, the mystery of God. And then food, good food. All of it together, all of us together, the whole ball of wax. It felt comfortable and perfect and as if everything was as it should be.

Tough to recognize a moment you'll long for one day when you're in it. Sure is.

Family Recipes

Spring Pea Salad

4 cups fresh or frozen, thawed
 green peas
½ cup shredded cheddar cheese
⅓ cup chopped red onion
½ teaspoon salt
¼ teaspoon pepper
½ cup ranch salad dressing
4 bacon strips, cooked crisp
 and crumbled

In a large bowl, combine peas, cheese, onion, salt, and pepper. Stir in salad dressing and mix well. Refrigerate, covered, for at least 30 minutes. Stir in bacon just before serving. Makes 6 servings.

Green Bean–Feta Salad

¼ cup olive oil
3 tablespoons fresh lemon juice
3 tablespoons balsamic vinegar
¼ teaspoon garlic powder
¼ teaspoon ground mustard
1 tablespoon plus ¼ teaspoon salt,
 divided
⅛ teaspoon ground black pepper
1½ pounds fresh green beans, trimmed
 and cut into 1½-inch pieces
½ cup thinly sliced red onion
2 cups halved cherry tomatoes
4 ounces crumbled feta cheese

In a small jar with tight lid, combine olive oil, lemon juice, vinegar, garlic powder, ground mustard, ¼ teaspoon salt, and pepper. Set aside. Fill a large bowl with ice and water and set aside. In a large pot, add 1 tablespoon salt to 8 cups of water and bring to a boil. Add beans, bring to a boil, and cook 8 to 10 minutes or until tender but not soft. Transfer to ice water to cool. Drain beans and wrap in paper towels to dry. In a large bowl, combine beans, onion, and tomatoes. Shake dressing to combine; add to beans and mix well. Add feta cheese just before serving. Makes 8 servings.

Pear-Arugula Salad

4 tablespoons honey
1 tablespoon fresh lemon juice
¼ cup Dijon mustard
¼ cup olive oil
4 tablespoons apple cider vinegar
½ teaspoon salt
¼ teaspoon pepper
4 cups arugula, friseé,
 or other salad green
2 pears, sliced
⅓ cup crumbled blue cheese
¼ cup chopped walnuts

In a small jar with tight lid, combine honey, lemon juice, mustard, olive oil, vinegar, salt, and pepper. Shake well and set aside. Arrange arugula in a large bowl. Top with pears, blue cheese, and walnuts. Just before serving, drizzle with dressing and toss together to combine. Makes 6 servings.

Fresh Asparagus Salad

1 tablespoon honey
1 tablespoon Dijon mustard
⅓ cup olive oil
2 tablespoons champagne vinegar
½ teaspoon salt
¼ teaspoon pepper
1 pound fresh asparagus, ends trimmed,
 cut into 1-inch pieces
⅔ cup halved cherry tomatoes
¼ cup sliced green onion
4 hard-boiled eggs, thinly sliced crosswise
6 slices of bacon, cooked crisp
 and crumbled

In a small jar with a tight lid, combine honey, mustard, olive oil, vinegar, salt, and pepper. Shake well and set aside. Fill a large bowl with ice and water and set aside. In a large pot, bring 6 cups of water to a boil. Add asparagus and cook 2 to 3 minutes, depending on thickness of asparagus, until just tender. Transfer to ice water to cool. Drain asparagus and wrap in paper towels to dry. Place asparagus in a large bowl; top with tomatoes and green onion. Drizzle dressing over top and toss to combine. Arrange egg slices and crumbled bacon on top. Makes 6 servings.

The Spring
Thomas Carew

Now that the winter's gone, the earth hath lost
her snow-white robes; and now no more the frost
candies the grass, or casts an icy cream
upon the silver lake or crystal stream;
but the warm sun thaws the benumbed earth,
and makes it tender; gives a second birth
to the dead swallow; wakes in hollow tree
the drowsy cuckoo, and the humble-bee.
Now do a choir of chirping minstrels sing
in triumph to the world, the youthful spring.
The valleys, hills, and woods in rich array
welcome the coming of the longed-for May.

The Smells of Spring
Mary E. Black

It smells like spring!" How often we have said that, but what does it mean?

It's the smell of a newly plowed field with freshly turned earth lying in neat furrows. It is a neighborhood whose freshly mown lawns erupt with the odors of cut grass and wild onions. When spring showers wash the world, the perfume of jonquils, narcissus, hyacinths, tulips, take to the air and our senses. Odors of spring combine with the brilliant sights of the world of springtime as the apple, cherry, and pear trees put on their spectacular display. Not to be outdone, the smell of spring returns with the sweetness of lilies of the valley, star magnolias, and orange blossoms. Finally spring's finale comes, as lilacs and irises, dressed in royal purples, and the showy hydrangeas of white, pink, and blue take the stage.

What priceless gift of smells and sights has God given us in spring!

Image © Aniszewski/Adobe Stock

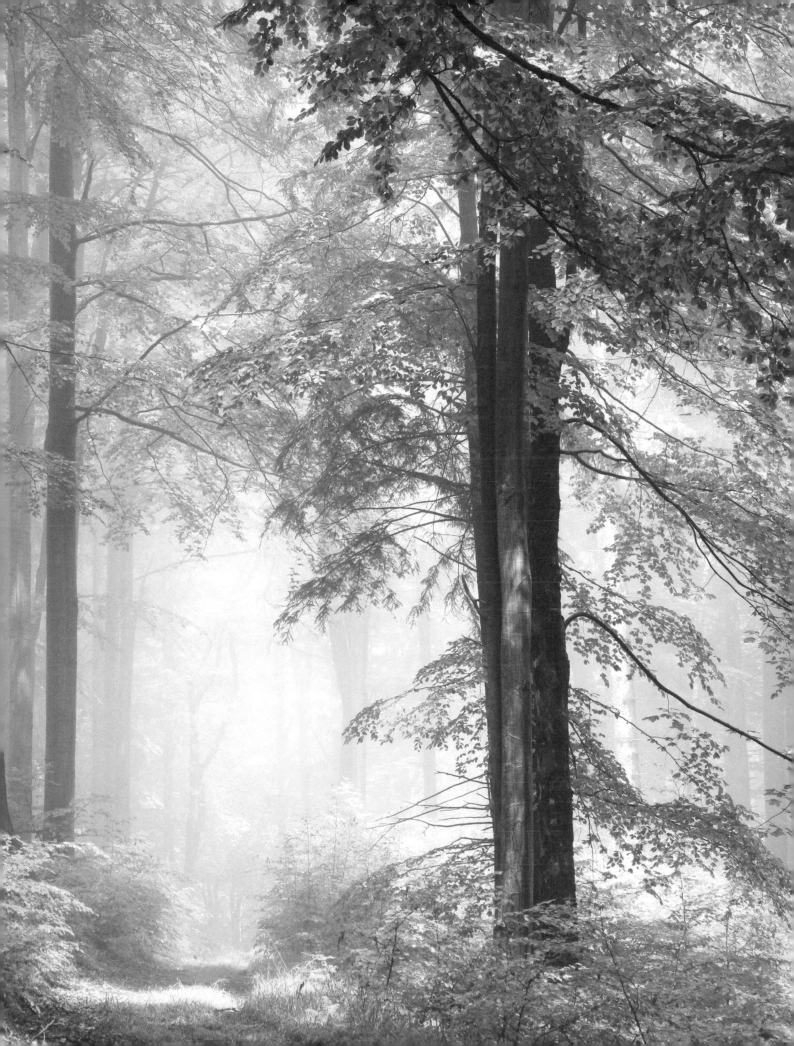

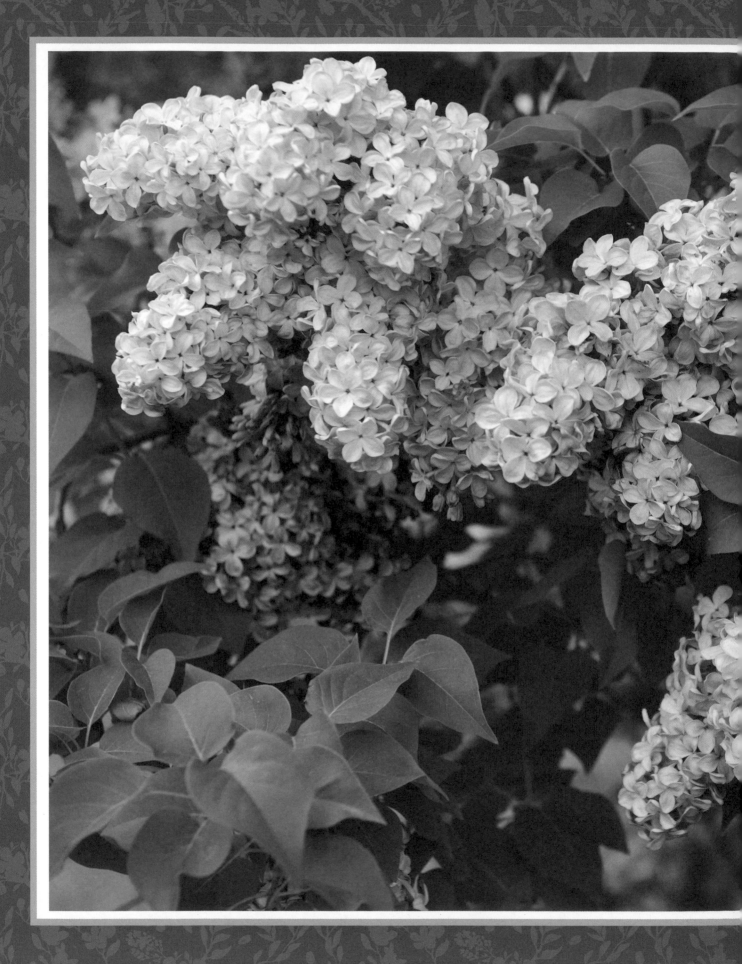

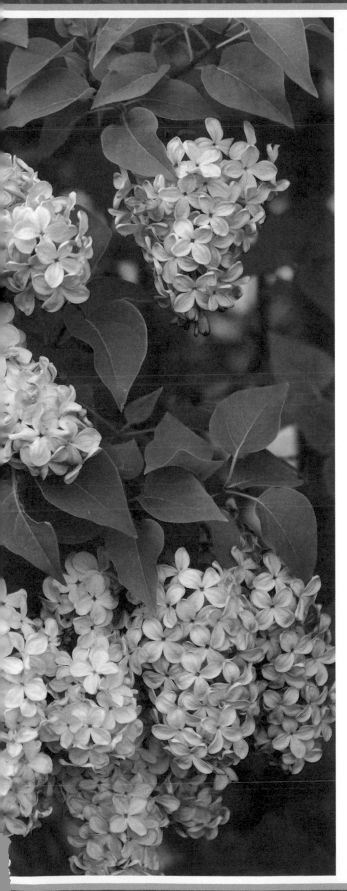

The Lilac's Fragrance

George L. Ehrman

The lilacs are in bloom again;
their fragrance greets the dawn
then touches every gypsy breeze
that dances on the lawn.
And then it comes in search of me,
no matter what I do,
to find a way into my heart
and set it dancing too!

Lilac Time

Brian F. King

High in the hills is a lovely lane
where sunbeams dance,
 where bluebirds sing;
where lilacs bright with gems of rain
wake to the kiss of the winds of spring.
Fragrant the scent of the sweet bouquets,
each purple bloom a fervent prayer
that love will dwell in the hills of home
to bless each heart that is sheltered there.

Easter Morning
Nina Gertrude Smith

If there had never been an Easter morn,
a bird would sing, I guess,
and somehow winter's gray would turn to gold
in springtime's gentle dress.

If there had never been a heavy stone
rolled from an empty tomb,
perhaps the dew would still lie fragrantly
upon a bough in bloom.

I cannot say that faith and love would die
if Easter came no more—
I only know this morning brings me hope
where there was none before.

ISBN-13: 978-1-5460-0657-2

Published by Ideals
Hachette Book Group
1290 Avenue of the Americas
New York, NY 10104

Printed in Canada

Publisher, Peggy Schaefer
Editor, Patricia A. Pingry
Senior Editor, Melinda Rathjen
Designer and Photo Research, Marisa Jackson
Editorial Assistant, Eliza McLaughlin
Proofreader, Kate Etue

Cover: Photograph © Sonia Hunt/GAP Photos.
Additional art credits: Art for "Bits & Pieces" by Emily van Wyk.
Inside front cover: *A Promise of Spring* by Joanne Porter. Image © Joanne Porter/Art Licensing.
Inside back cover: *Iris in a Rock Garden* by Joanne Porter. Image © Joanne Porter/Art Licensing.

Want more homey philosophy, poetry, inspiration, and art? Be sure to look for our annual issue of *Christmas Ideals* at your favorite store.

Join a community of readers on Facebook at: www.facebook.com/IdealsMagazine.
Readers are invited to submit original poetry and prose for possible use in future publications. Please send no more than four typed submissions to: Hachette Book Group, Attn: Ideals Submissions, 830 Crescent Centre Drive, Suite 450, Franklin, Tennessee 37067. Editors cannot guarantee your material will be used, but we will contact you if we do wish to publish.

ACKNOWLEDGMENTS

BORLAND, HAL. "Hepaticas" excerpted from *Twelve Moons of the Year*. Copyright © 1979 by Barbara Dodge Borland, as executor of the estate of Hal Borland. Used by permission of Yake Literary Management LLC. MARSHALL, PETER. "We Thank Thee," excerpt from *The Prayers of Peter Marshall* by Peter Marshall, copyright © 1954, 1982. Used by permission of Chosen Books, a division of Baker Publishing Group.

OUR THANKS to the following authors or their heirs for permission granted or for material submitted for publication: Faith Andrews Bedford, Mary E. Black, Frances Bowles, Anne Kennedy Brady, George L. Ehrman, Georgia M. Emmert, Frances Frost, Linda C. Grazulis, Holly Harden, Rebecca Barlow Jordan, Pamela Kennedy, Brian F. King, Laverne P. Larson, Andrew L. Luna, Garnett Ann Schultz, Nina Gertrude Smith, Susan Sundwall, and Marion Weaver.

Scripture quotations, unless otherwise indicated, are taken from the King James Version of the Bible (KJV). Scripture quotations marked ESV are taken from the ESV® Bible (The Holy Bible, English Standard Version®), copyright © 2001 by Crossway, a publishing ministry of Good News Publishers. Used by permission. All rights reserved.

Every effort has been made to establish ownership and use of each selection in this book. If contacted, the publisher will be pleased to rectify any inadvertent errors or omissions in subsequent editions.